DESIGNER'S GUIDE TO

color
2

Introductory Essay by James Stockton

Chronicle Books San Francisco

First published in the United States 1984 by
Chronicle Books
275 Fifth Street
San Francisco, CA 94103

Printed in Japan.

Haishoku Jiten by Ikuyoshi Shibukawa
and Yumi Takahashi
Copyright © 1984 by Kawade Shobo
Shinsha Publishers

Library of Congress
Cataloging in Publication Data
Main entry under title:

Designer's guide to color. II.

Based on: Haishoku jiten by Ikuyoshi
Shibukawa and Yumi Takahashi, 1984.
1. Color in art. 2. Color. 3. Color—
Psychological aspects. I. Stockton, James.
II. Shibukawa, Ikuyoshi. Haishoku jiten.
ND1488.D475 1984 701′.8 84-21482
ISBN 0-87701-345-4

10 9

Introduction

This second volume of *Designer's Guide to Color* is an extension of the first book, a careful, thorough look at more complicated color examples than were treated before. While the first book was basic and clinical, this one deals with the more personal, emotional aspects of color.

In this book, colors have been grouped together—pastels through deep tones as the pages progress. At the bottom of each page are two color squares with polka dots. These demonstrate how shape and size relationships affect color. And from page 78 to the end of this book, the possible combinations of color become interestingly complex by being presented in groups of three.

The adjectives used in the table of contents are for the reader's convenience and are an attempt to qualify the colors presented. Most of the terms are standard enough to be self-explanatory; however, the following terms are used in these specific ways: *Bright*—intense, light valued, transparent; receiving their brightness from the clean whiteness of the paper (much as a watercolor might). See pages 28 through 31. *Brilliant*—intense, strong pigment; a reflected color (more like an oil painting). See pages 36 and 37. *Medium*—soothing and subtle. See pages 76 and 77. *Deep*—rich and elegant. See pages 52 through 55. *Dark*—similar to deep but with much more black added to the colors. See pages 70 and 71. *Subdued*—grayed through either the addition of black, white, or a neutralizing complementary color. See pages 66 through 69. *Concentrated*—intense with strong hue, value, and intensity all combined. See pages 56 through 59. *Clear*—free of graying qualities; can probably be found on the basic color wheel. See volume one.

Short anecdotes accompany the color combinations. They are sometimes instructional, sometimes an attempt to articulate the motives for combining the colors. They may stimulate ideas and suggest extended uses of original combinations.

As in volume one, the colors in this book are produced by combining tint values—that is, screen values—of the four basic printing process colors. Each color is accompanied by the numbers designating those values, and abbreviated designations for the four colors are given with the percentages: Y stands for yellow, M for magenta, C for cyan, and BL or K for black.

To achieve strong areas of flat-colors similar to these color samples, percentages of the same four basic process colors can be printed in almost endless combinations. But it is very important to remember that while the method for reproducing the four process colors is basically the same for lithography and letterpress printing worldwide, the chemical composition and properties of inks and paper vary somewhat from country to country and even from printer to printer.

In the early 1960's, the idea that quick, effective, and relatively inexpensive architectural embellishment could be obtained through

painted surfaces gave rise to brightly colored building exteriors and interiors. Architectural graphics flourished. Today the use of color in architecture and interior design has developed almost exactly parallel to the emergence of postmodernism and ornamentalism. In these two areas color is often either the signal or the confirmation of the designer's intent.

Trendy and fashionable, yes; but these uses of color also set the stage, reinforce the statement, and send the message. The freedom and eclecticism in current fashion derive greater support and vitality from color combinations and variation than from any other influence.

In all of these areas, color doesn't necessarily mean bright color. Enormously satisfying color use and vitality can be found almost anywhere these days: new and renewed buildings, commercial interiors, fashion for any age group, office furniture, and sensitive residential interiors. The most successful color combinations are usually personal and original, muted and subdued. A sense of scale and emphasis applies to color just as it does to size proportion and position in art and music. That is, a small patch of bright color placed next to pale or grayed colors can accentuate their contribution.

The main value of this book is in presenting a large array of color combinations for evaluation and experimentation. Colors are evocative and emotional, and in combinations they can trigger reactions and responses in somewhat the same way letters of the alphabet can combine to spell out messages. There are color combinations here that are absolutely unprecedented by history or tradition, but they work and augment each other in surprising ways. Only individual judgment and preference can determine the most successful and appealing examples. There are enough color examples here to satisfy a passive observer who doesn't need to carry the investigation further, and there certainly is plenty of material to encourage and stimulate additional color innovation.

This book is an invitation to look at color in new ways, to perceive color differently and more acutely, to experiment, and to enjoy.

Table of Contents
Two-color combinations

18-19
Medium Grays

6-7
Very Pale Colors

20-25
Free Combinations of Bright Colors

8-9
Pale Clear Colors

26-27
Bright Subdued Colors

10-11
Free Combinations

28-31
Vivid and Bright Colors

12
Silver Gray

32-33
Slate Gray

13
Pale and Subdued Colors

34-37
Vivid Colors

14-17
Bright Clear Colors

How to use this book

In this book, color schemes that use the same qualities are grouped together, for example, "Bright Clear Colors" (pp14-17) are all bright pastels, but it is also obvious that each combination is somehow different. And speaking of color differences, even though you may be making a multiple color scheme, you'll want to strive for similarities in tone quality in order to achieve an overall harmonious effect.

For color classifications, please refer to the Table of Contents on these first few pages.

38-41
Bright with Vivid Colors

61-63
Bright with Concentrated
Colors (1)

42-45
Vivid with Concentrated
Colors

64-65
Bright with Concentrated
Colors (2)

46-51
Medium Colors

66-69
Subdued Colors

70-71
Dark Colors

52-55
Deep Colors

72-73
Black with Vivid Colors

56-59
Concentrated Colors

74-75
Black with Concentrated
Colors

60
Charcoal Gray

76-77
Black with Medium
Colors

Soft tones are first, followed by tones grouped in order of increasing intensity of color. Falling in the middle are the gray color schemes and contrasting color schemes including some unique combinations.

As an exercise, take a sample tone from the book and compare it to those in the Table of Contents, to get a feel for the arrangement of this book.

The essence of the book is to experiment with colors.

Contents
Three-color combinations

78-79
Pale Colors

80-82
Bright Colors

83
Bright Subdued Colors

84-85
Effects of Gradation

86-87
Bright Vivid Colors

88-91
More Vivid Colors

92-93
**Vivid Colors plus a
Neutral**

94-95
**Vivid Colors plus
Concentrated Colors (1)**

96-97
**Vivid Colors plus
Concentrated Colors (2)**

98-99
Deep Colors (1)

100-101
Deep Colors (2)

102-103
Deep Colors (3)

104-105
Dark Subdued Colors

106-107
Black—Gray—White

108-109
Effects of Contrast (1)

110-111
Effects of Contrast (2)

112-115
Free Color Schemes (1)

116-117
Free Color Schemes (2)

118
Black and Vivid Colors

119
Black and Deep Colors

120-121
Black and Medium
Colors

122-123
White and Vivid Colors

124-125
White with Other Colors

126
Appendix:
Concentration Scale

127
Appendix:
Color Progressions

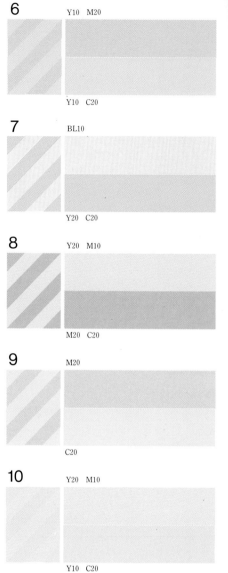

Very Pale Colors

The differences among the very light colors are subtle and sometimes hard to grasp. However, softer colors are easy to combine: don't worry about colors matching, as long as they convey the same overall message. For instance, in examples 4, 7, and 16 bright gray in combination produces a slightly cool feeling.

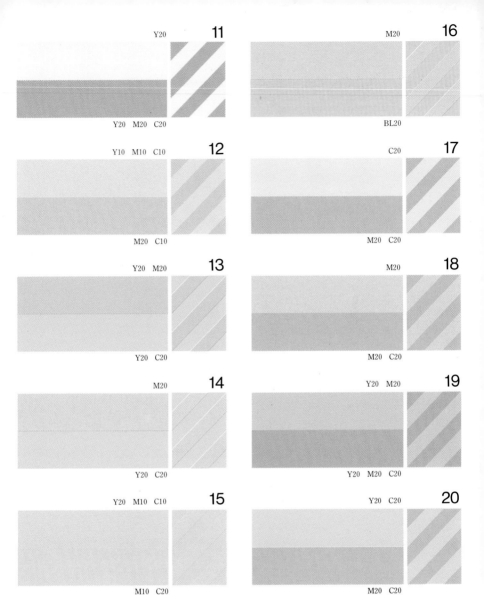

Y20 **11**

Y20 M20 C20

M20 **16**

BL20

Y10 M10 C10 **12**

M20 C10

C20 **17**

M20 C20

Y20 M20 **13**

Y20 C20

M20 **18**

M20 C20

M20 **14**

Y20 C20

Y20 M20 **19**

Y20 M20 C20

Y20 M10 C10 **15**

M10 C20

Y20 C20 **20**

M20 C20

C30 M30

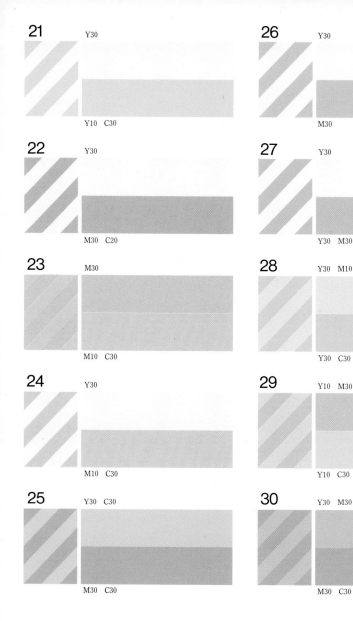

21
Y30
Y10 C30

22
Y30
M30 C20

23
M30
M10 C30

24
Y30
M10 C30

25
Y30 C30
M30 C30

26
Y30
M30

27
Y30
Y30 M30

28
Y30 M10
Y30 C30

29
Y10 M30
Y10 C30

30
Y30 M30
M30 C30

Pale Clear Colors

These light colors have a transparent, cool quality, even though many are from a warm color family. In a dot, stripe, or checkered pattern, the sherbet tones can seem warm, sweet, and sometimes softly sedate.

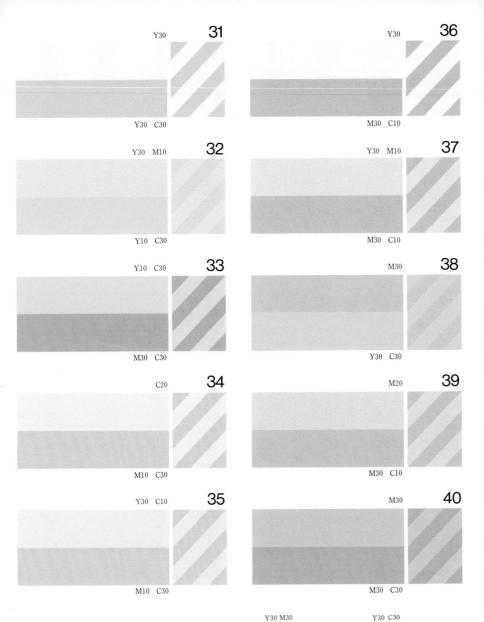

31 Y30 / Y30 C30

32 Y30 M10 / Y10 C30

33 Y10 C30 / M30 C30

34 C20 / M10 C30

35 Y30 C10 / M10 C30

36 Y30 / M30 C10

37 Y30 M10 / M30 C10

38 M30 / Y30 C30

39 M20 / M30 C10

40 M30 / M30 C30

Y30 M30 Y30 C30

9

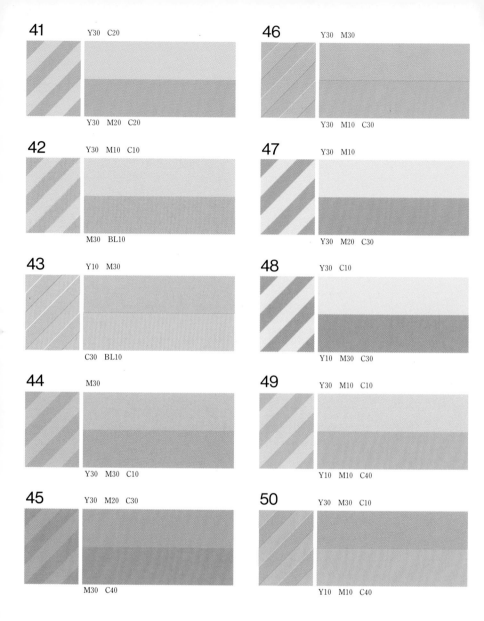

41 Y30 C20

Y30 M20 C20

42 Y30 M10 C10

M30 BL10

43 Y10 M30

C30 BL10

44 M30

Y30 M30 C10

45 Y30 M20 C30

M30 C40

46 Y30 M30

Y30 M10 C30

47 Y30 M10

Y30 M20 C30

48 Y30 C10

Y10 M30 C30

49 Y30 M10 C10

Y10 M10 C40

50 Y30 M30 C10

Y10 M10 C40

Free Combinations

These lighter, duller neutral colors are restful to look at. They may be subdued, but they avoid being melancholy because they contain some degree of brightness.

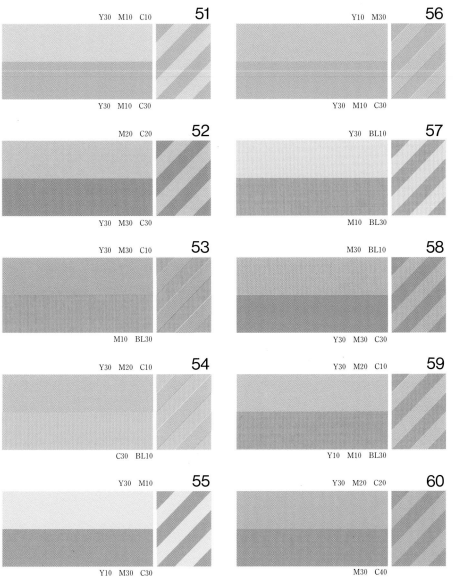

Y30 M10 C10　**51**

Y30 M10 C30

Y10 M30　**56**

Y30 M10 C30

M20 C20　**52**

Y30 M30 C30

Y30 BL10　**57**

M10 BL30

Y30 M30 C10　**53**

M10 BL30

M30 BL10　**58**

Y30 M30 C30

Y30 M20 C10　**54**

C30 BL10

Y30 M20 C10　**59**

Y10 M10 BL30

Y30 M10　**55**

Y10 M30 C30

Y30 M20 C20　**60**

M30 C40

Y30 M10　　　　M30 C30

11

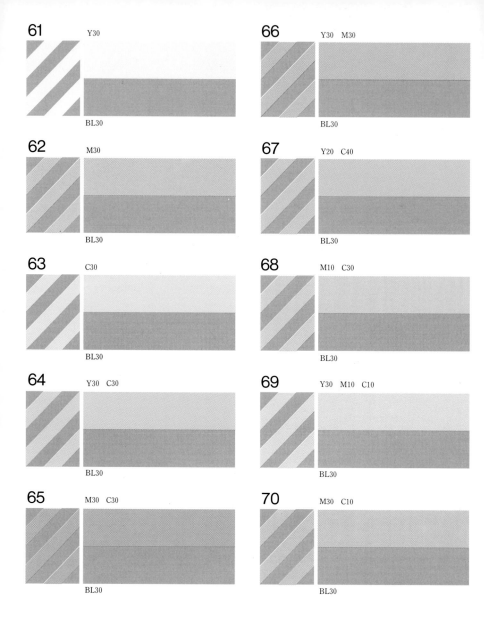

61 Y30 / BL30

66 Y30 M30 / BL30

62 M30 / BL30

67 Y20 C40 / BL30

63 C30 / BL30

68 M10 C30 / BL30

64 Y30 C30 / BL30

69 Y30 M10 C10 / BL30

65 M30 C30 / BL30

70 M30 C10 / BL30

Silver Gray

The addition of silver gray creates cool, elegant, pretty combinations. In Japan, these are typical spring color schemes. For greater contrast, try darker gray.

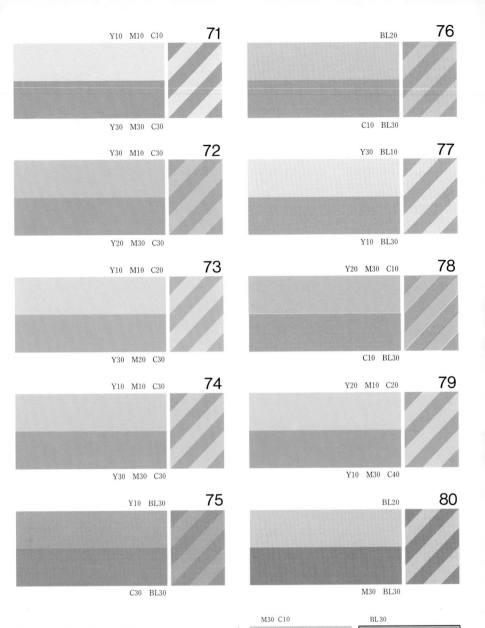

71 Y10 M10 C10 / Y30 M30 C30

76 BL20 / C10 BL30

72 Y30 M10 C30 / Y20 M30 C30

77 Y30 BL10 / Y10 BL30

73 Y10 M10 C20 / Y30 M20 C30

78 Y20 M30 C10 / C10 BL30

74 Y10 M10 C30 / Y30 M30 C30

79 Y20 M10 C20 / Y10 M30 C40

75 Y10 BL30 / C30 BL30

80 BL20 / M30 BL30

Pale and Subdued Colors

Often these quiet and stately colors are even more elegant against a black background.

M30 C10 BL30

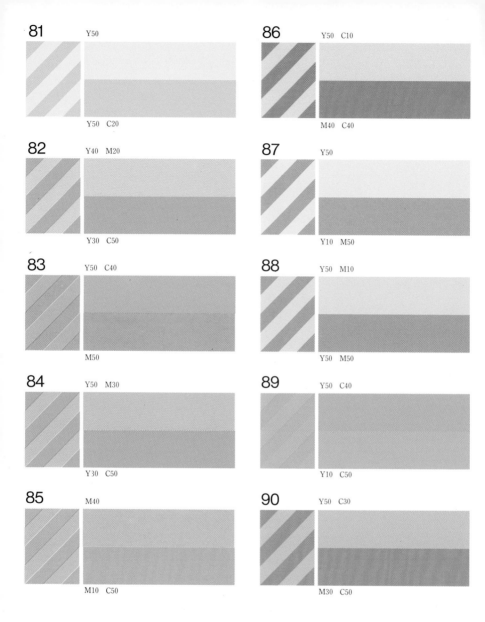

81 Y50 / Y50 C20

82 Y40 M20 / Y30 C50

83 Y50 C40 / M50

84 Y50 M30 / Y30 C50

85 M40 / M10 C50

86 Y50 C10 / M40 C40

87 Y50 / Y10 M50

88 Y50 M10 / Y50 M50

89 Y50 C40 / Y10 C50

90 Y50 C30 / M30 C50

Bright Clear Colors

These bright and healthy colors have a degree of brilliance. This grouping also has a powdery quality. Think of them as young colors for spring casual wear, for romantic storybook pictures, or for evoking a tropical feeling.

14

91 Y50 / M40 C30

92 Y50 / Y50 C50

93 Y10 M50 / Y10 C50

94 Y30 M50 / Y30 C50

95 Y50 C40 / Y50 M40

96 Y50 M10 / C50

97 Y10 C50 / M50 C30

98 C50 / M30 C50

99 M50 / Y30 C50

100 M50 C30 / M30 C50

Y50 C20

Y50 C20

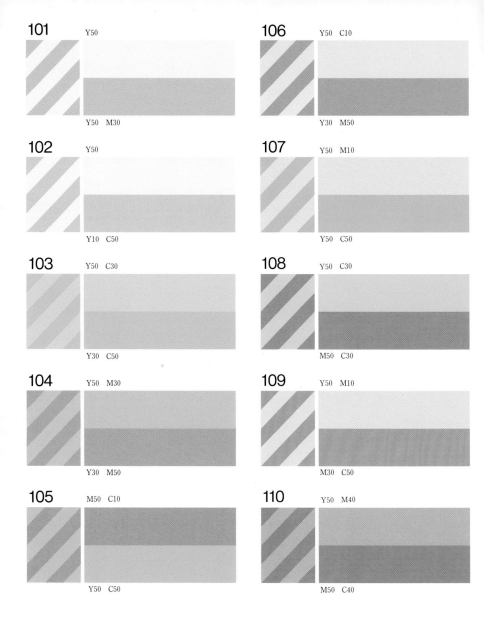

101 Y50

Y50 M30

102 Y50

Y10 C50

103 Y50 C30

Y30 C50

104 Y50 M30

Y30 M50

105 M50 C10

Y50 C50

106 Y50 C10

Y30 M50

107 Y50 M10

Y50 C50

108 Y50 C30

M50 C30

109 Y50 M10

M30 C50

110 Y50 M40

M50 C40

Bright Clear Colors (continued)

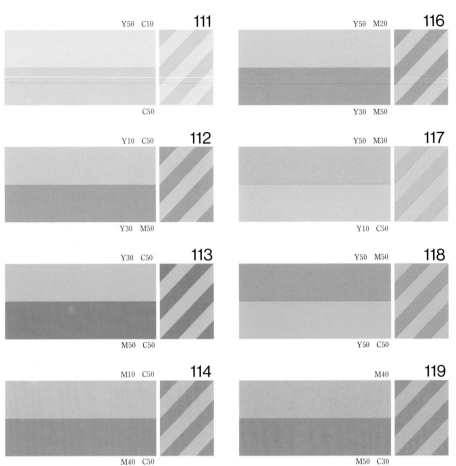

Y50 C10 **111**
C50

Y50 M20 **116**
Y30 M50

Y10 C50 **112**
Y30 M50

Y50 M30 **117**
Y10 C50

Y30 C50 **113**
M50 C50

Y50 M50 **118**
Y50 C50

M10 C50 **114**
M40 C50

M40 **119**
M50 C30

M50 **115**
M30 C50

Y30 M50 **120**
M30 C50

M50 C10
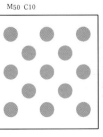

M50 C10
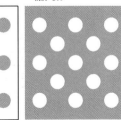

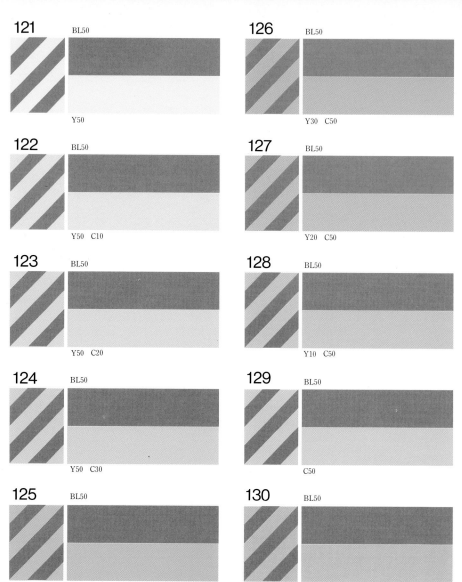

121 BL50 / Y50	**126** BL50 / Y30 C50
122 BL50 / Y50 C10	**127** BL50 / Y20 C50
123 BL50 / Y50 C20	**128** BL50 / Y10 C50
124 BL50 / Y50 C30	**129** BL50 / C50
125 BL50 / Y50 C50	**130** BL50 / M10 C50

Medium Grays

Use gray as an accent as well as a principal color. Medium gray is especially good for enhancing other colors (if you aren't sure what color to use, try gray first). The colors and gray on these pages contain the same degree of brightness, and the resulting combinations achieve a balance between quiet gray and bright color.

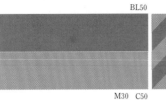

BL50 **131**

M30 C50

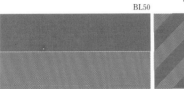
BL50 **132**

M50 C50

BL50 **133**

M50 C30

BL50 **134**

M50 C10

BL50 **135**

M50

BL50 **136**

Y10 M50

BL50 **137**

Y30 M50

BL50 **138**

Y50 M50

BL50 **139**

Y50 M30

BL50 **140**

Y50 M10

Y20 C50 Y20 C50

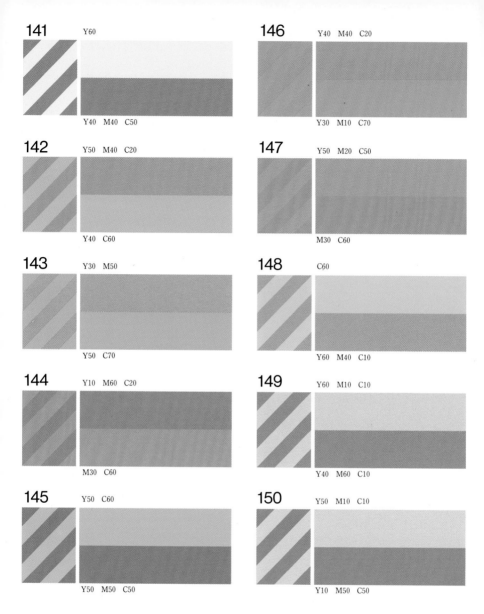

141 Y60

Y40 M40 C50

142 Y50 M40 C20

Y40 C60

143 Y30 M50

Y50 C70

144 Y10 M60 C20

M30 C60

145 Y50 C60

Y50 M50 C50

146 Y40 M40 C20

Y30 M10 C70

147 Y50 M20 C50

M30 C60

148 C60

Y60 M40 C10

149 Y60 M10 C10

Y40 M60 C10

150 Y50 M10 C10

Y10 M50 C50

Free Combinations of Bright Colors
These color combinations have a broad range of applications, from interior design to fashion. Bright colors are placed next to dull colors, but each has enough brightness to make the mix lively.

Y50 M50 **151**

Y60 M20 C40

Y20 M30 C10 **156**

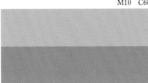

Y30 M60

Y20 C50 **152**

Y20 M40 C40

M10 C60 **157**

Y30 M40 C50

Y30 C60 **153**

Y30 M60

Y40 C60 **158**

Y50 M40 C70

M60 **154**

Y40 M30 C60

Y60 M60 **159**

Y60 M60 C50

Y40 C50 **155**

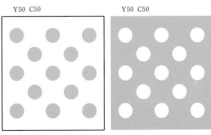

M10 C60

Y10 M60 **160**

Y60 M40 C40

Y50 C50

Y50 C50

21

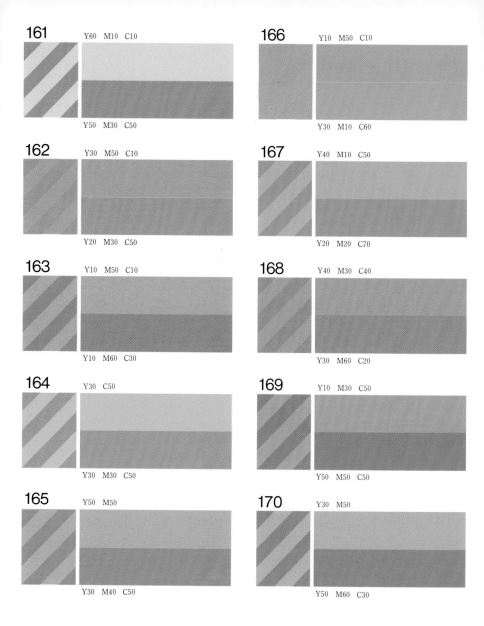

161 Y60 M10 C10

Y50 M30 C50

166 Y10 M50 C10

Y30 M10 C60

162 Y30 M50 C10

Y20 M30 C50

167 Y40 M10 C50

Y20 M20 C70

163 Y10 M50 C10

Y10 M60 C30

168 Y40 M30 C40

Y30 M60 C20

164 Y30 C50

Y30 M30 C50

169 Y10 M30 C50

Y50 M50 C50

165 Y50 M50

Y30 M40 C50

170 Y30 M50

Y50 M60 C30

Free Combinations of Bright Colors
(continued)

22

Y40 M10 C30 **171**

Y50 M10 C60

Y30 M50 C10 **172**

Y30 M10 C50

Y40 M40 C30 **173**

Y20 M30 C70

Y10 M50 C10 **174**

Y30 M60 C60

Y60 M40 C20 **175**

Y30 M40 C70

Y40 M20 C20 **176**

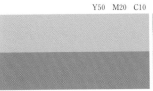

Y30 M50 C10

Y50 M20 C10 **177**

Y40 M40 C50

Y50 M50 **178**

Y50 M50 C50

Y10 M10 C50 **179**

Y30 M30 C70

M10 C50 **180**

Y40 M50 C50

Y30 M50 Y30 M50

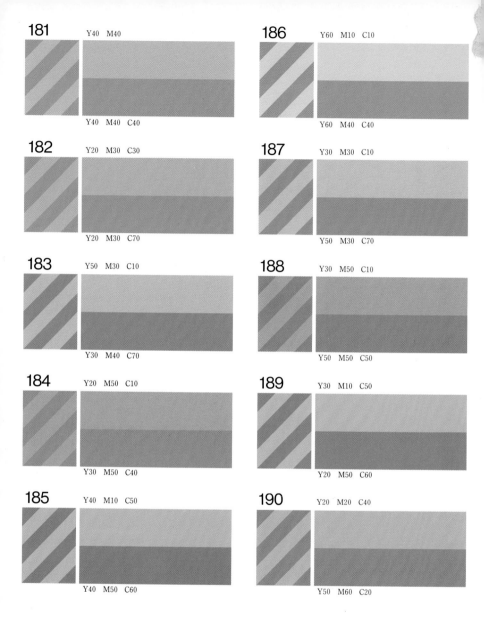

181 Y40 M40

Y40 M40 C40

182 Y20 M30 C30

Y20 M30 C70

183 Y50 M30 C10

Y30 M40 C70

184 Y20 M50 C10

Y30 M50 C40

185 Y40 M10 C50

Y40 M50 C60

186 Y60 M10 C10

Y60 M40 C40

187 Y30 M30 C10

Y50 M30 C70

188 Y30 M50 C10

Y50 M50 C50

189 Y30 M10 C50

Y20 M50 C60

190 Y20 M20 C40

Y50 M60 C20

Free Combinations of Bright Colors
(continued)

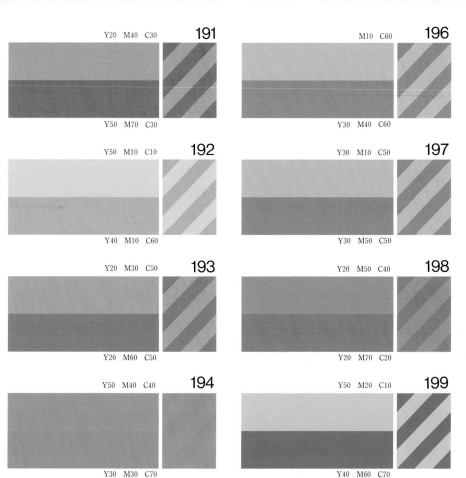

Y20 M40 C30 **191**

Y50 M70 C30

M10 C60 **196**

Y30 M40 C60

Y50 M10 C10 **192**

Y40 M10 C60

Y30 M10 C50 **197**

Y30 M50 C50

Y20 M30 C50 **193**

Y20 M60 C50

Y20 M50 C40 **198**

Y20 M70 C20

Y50 M40 C40 **194**

Y30 M30 C70

Y50 M20 C10 **199**

Y40 M60 C70

Y20 M60 C30 **195**

Y30 M40 C60

Y10 M50 C40 **200**

Y60 M50 C70

M30 C50

M30 C50

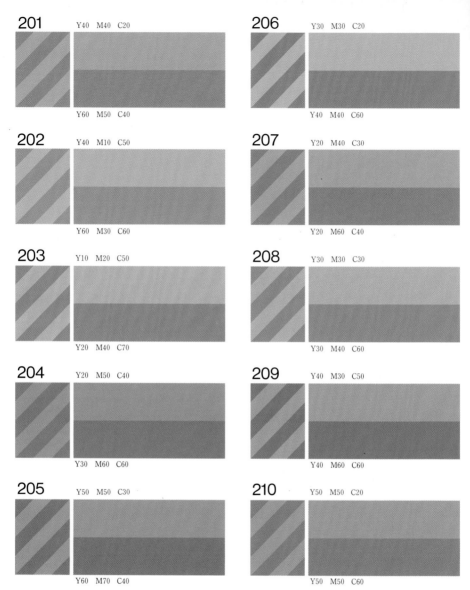

201 Y40 M40 C20 / Y60 M50 C40

206 Y30 M30 C20 / Y40 M40 C60

202 Y40 M10 C50 / Y60 M30 C60

207 Y20 M40 C30 / Y20 M60 C40

203 Y10 M20 C50 / Y20 M40 C70

208 Y30 M30 C30 / Y30 M40 C60

204 Y20 M50 C40 / Y30 M60 C60

209 Y40 M30 C50 / Y40 M60 C60

205 Y50 M50 C30 / Y60 M70 C40

210 Y50 M50 C20 / Y50 M50 C60

Bright Subdued Colors

Even though colors may be subdued, they can still contrast. (To remove the color contrast completely, choose analogous colors of the same intensity.)

Combining bright and subdued colors is a challenge. It is important to consider the characteristics, personality, and possible emotional context of each color. Exam-

ples 201 through 205 pair colors within the same family, while examples 211 through 220 show subdued colors from different families—very effective in the right setting.

26

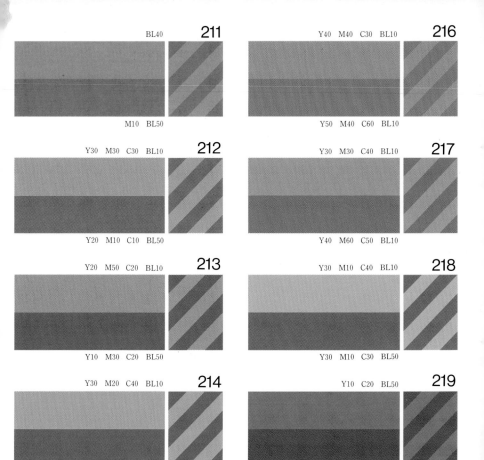

BL40 **211**

M10 BL50

Y40 M40 C30 BL10 **216**

Y50 M40 C60 BL10

Y30 M30 C30 BL10 **212**

Y20 M10 C10 BL50

Y30 M30 C40 BL10 **217**

Y40 M60 C50 BL10

Y20 M50 C20 BL10 **213**

Y10 M30 C20 BL50

Y30 M10 C40 BL10 **218**

Y30 M10 C30 BL50

Y30 M20 C40 BL10 **214**

Y10 C50 BL50

Y10 C20 BL50 **219**

Y10 M60 BL50

Y40 M40 C40 BL10 **215**

Y30 M30 C20 BL50

Y10 M30 BL50 **220**

Y20 M20 C40 BL50

Y50 M40 C30

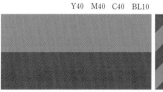

Y50 M40 C30

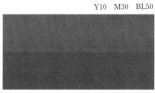

221 Y70

Y70 C30

222 Y70 M10

Y50 C70

223 Y70 M30

M70

224 Y70 C70

M10 C70

225 Y70 C30

M70 C70

226 Y70 C10

Y50 M70

227 Y70 C30

Y10 C70

228 M70

Y50 C70

229 Y10 M70

M30 C70

230 Y70 M50

M30 C70

Vivid and Bright Colors

Visions of fresh fruit spring to mind with
these bright and light-hearted pastels.
These are young, tropical color schemes;
in fashion they might be used for casual
spring and summer wear.

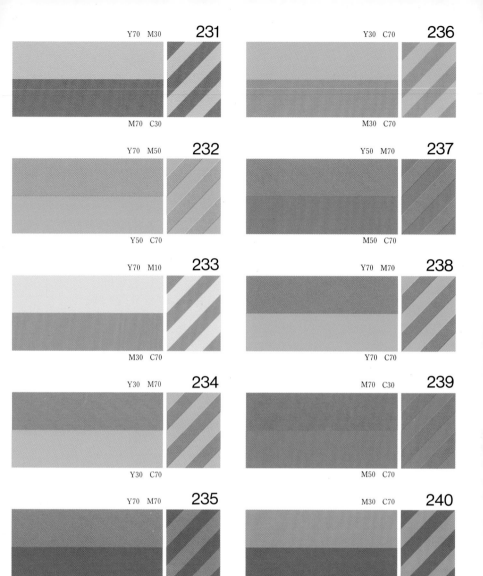

Y70 M30 **231**

M70 C30

Y30 C70 **236**

M30 C70

Y70 M50 **232**

Y50 C70

Y50 M70 **237**

M50 C70

Y70 M10 **233**

M30 C70

Y70 M70 **238**

Y70 C70

Y30 M70 **234**

Y30 C70

M70 C30 **239**

M50 C70

Y70 M70 **235**

M70 C70

M30 C70 **240**

M70 C70

Y50 C70
Y70 M10

Y70 M10
Y50 C70

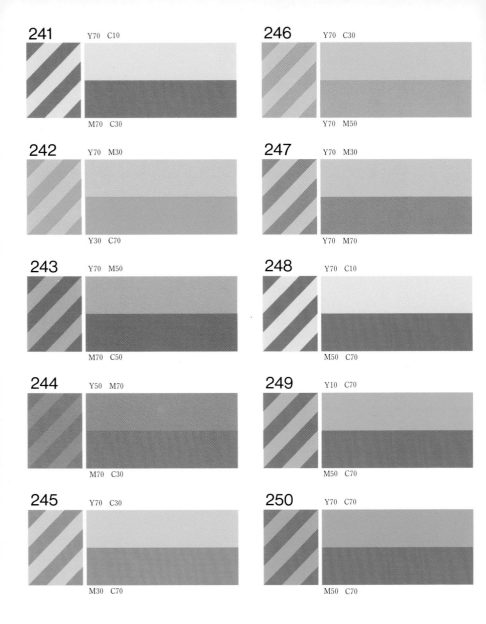

241 Y70 C10
M70 C30

246 Y70 C30
Y70 M50

242 Y70 M30
Y30 C70

247 Y70 M30
Y70 M70

243 Y70 M50
M70 C50

248 Y70 C10
M50 C70

244 Y50 M70
M70 C30

249 Y10 C70
M50 C70

245 Y70 C30
M30 C70

250 Y70 C70
M50 C70

Vivid and Bright Colors (continued)

M70 C10 **251**

Y30 C70

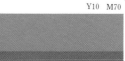

Y10 M70 **256**

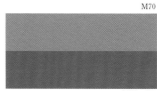

M70 C50

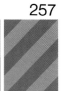

Y70 M50 **252**

M70 C10

M70 **257**

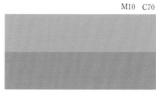

M70 C70

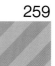

Y50 C70 **253**

M70 C50

C70 **258**

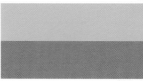

M70 C30

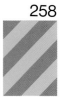

Y70 M30 **254**

M70 C70

M10 C70 **259**

M30 C70

Y30 C70 **255**

M70 C70

M70 C50 **260**

M70 C70

M70 C70
M70

M70
M70 C70

31

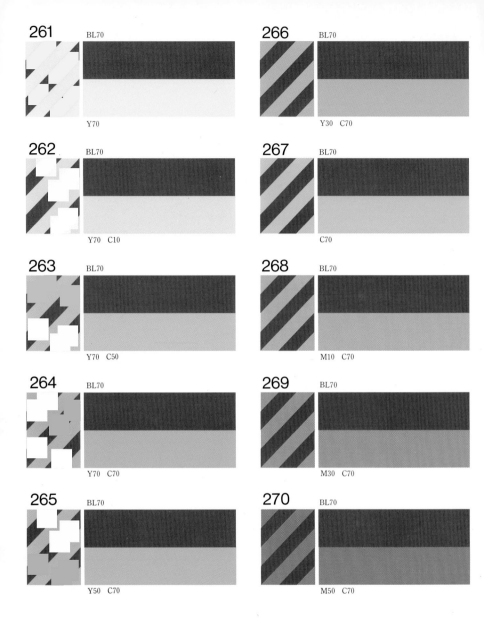

261 BL70 / Y70

262 BL70 / Y70 C10

263 BL70 / Y70 C50

264 BL70 / Y70 C70

265 BL70 / Y50 C70

266 BL70 / Y30 C70

267 BL70 / C70

268 BL70 / M10 C70

269 BL70 / M30 C70

270 BL70 / M50 C70

Slate Gray

Slate gray is between medium and charcoal gray. Technically, gray is considered to be colorless (like black or white); but in terms of color schemes, it falls in the blue family, especially the dark and near-black grays. Matched here with either related cool colors or contrasting with warm colors, slate gray produces startling effects.

If cloth is dyed gray, it turns either slightly reddish or bluish. For a purer gray color, cotton or wool is usuallly first bleached white or dyed black—a process called *topping*—then made into various shades of gray by adding a mixture of black and white.

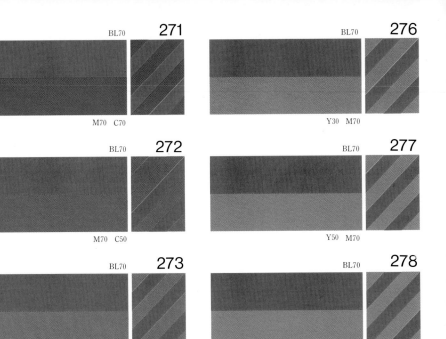

BL70 **271** M70 C70

BL70 **276** Y30 M70

BL70 **272** M70 C50

BL70 **277** Y50 M70

BL70 **273** M70 C30

BL70 **278** Y70 M70

BL70 **274** M70 C10

BL70 **279** Y70 M50

BL70 **275** M70

BL70 **280** Y70 M30

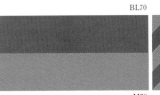

BL70
Y30 C70

Y30 C70
BL70

33

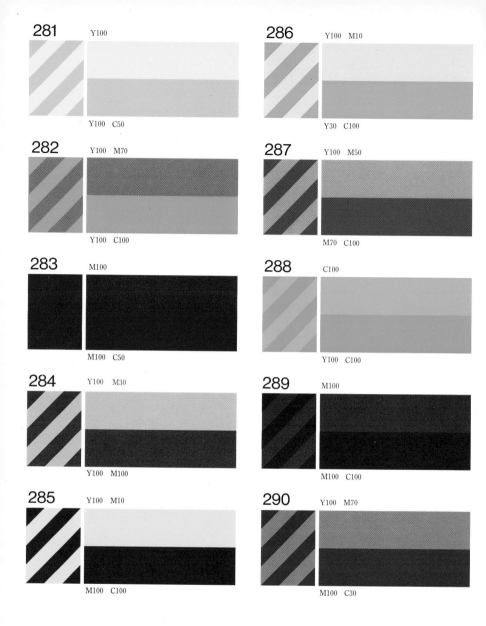

281 Y100 / Y100 C50

286 Y100 M10 / Y30 C100

282 Y100 M70 / Y100 C100

287 Y100 M50 / M70 C100

283 M100 / M100 C50

288 C100 / Y100 C100

284 Y100 M30 / Y100 M100

289 M100 / M100 C100

285 Y100 M10 / M100 C100

290 Y100 M70 / M100 C30

Vivid Colors

These color schemes use strong primary colors that broadcast a very clear message. Each color has very distinct characteristics, and reactions to these combinations are more specific than they are to subtle colors. The combinations here suggest heat, health, vitality, aggressiveness, humor, fun, sporting events, citrus flavors,

and some current high fashion. Their charm lies in boldness and beauty, so use them in big, dramatic ways.

Color brilliance is relative to the medium used: 100% colors look far more brilliant in printing than they do in paints or dyes, and the same color can look quite different if printed on silk or cotton.

34

Y100 C70 **291**

M30 C100

Y100 C70 **292**

M100

M100 C30 **293**

Y30 C100

Y30 M100 **294**

Y50 C100

Y100 M70 **295**

Y30 C100

Y100 M70 **296**

M30 C100

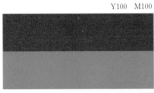

Y100 M100 **297**

M30 C100

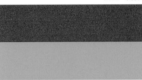

Y100 M100 **298**

Y100 C100

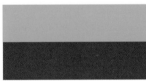

Y50 C100 **299**

M100 C70

Y100 C100 **300**

M100 C100

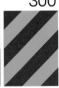

Y100 M100

Y100 M100

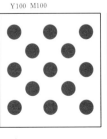

35

301
Y100

Y100　C100

306
Y100　M50

Y100　C70

302
Y100

M30　C100

307
Y100　C30

Y30　M100

303
Y100　M30

M100

308
Y100　C30

M100　C70

304
M100

M30　C100

309
M100　C30

Y100　C100

305
Y30　C100

M100　C100

310
Y100　M70

M100　C70

Vivid Colors (continued)

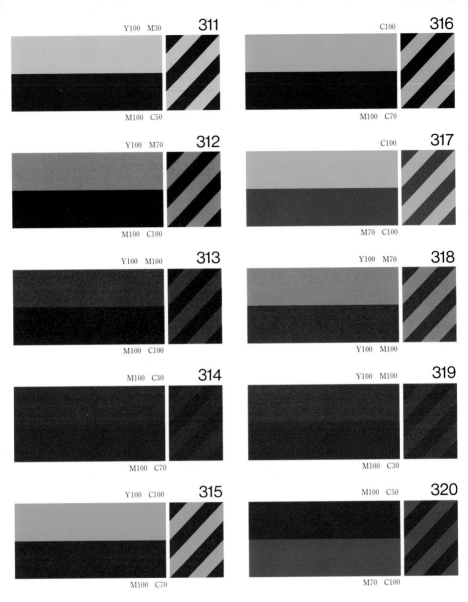

Y100 M30 **311**

M100 C50

Y100 M70 **312**

M100 C100

Y100 M100 **313**

M100 C100

M100 C30 **314**

M100 C70

Y100 C100 **315**

M100 C70

C100 **316**

M100 C70

C100 **317**

M70 C100

Y100 M70 **318**

Y100 M100

Y100 M100 **319**

M100 C30

M100 C50 **320**

M70 C100

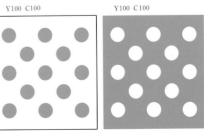

Y100 C100

Y100 C100

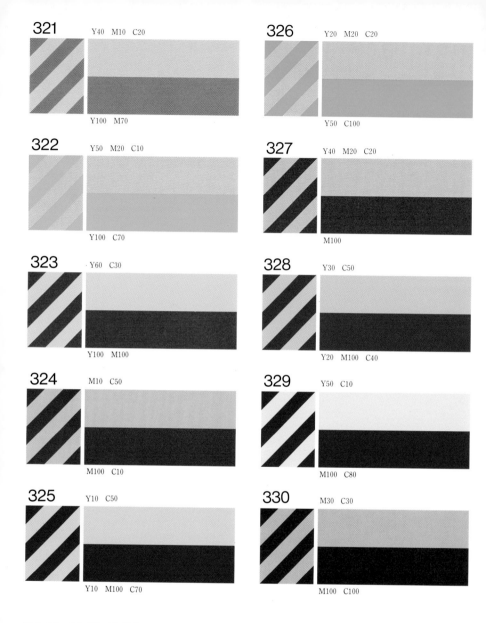

321 Y40 M10 C20 / Y100 M70

326 Y20 M20 C20 / Y50 C100

322 Y50 M20 C10 / Y100 C70

327 Y40 M20 C20 / M100

323 Y60 C30 / Y100 M100

328 Y30 C50 / Y20 M100 C40

324 M10 C50 / M100 C10

329 Y50 C10 / M100 C80

325 Y10 C50 / Y10 M100 C70

330 M30 C30 / M100 C100

Bright with Vivid Colors

These contrasting color schemes use colors with very similar levels of brightness and brilliance. Some have gorgeous effects, some seem sweet or frivolous. They are best used as highlights in a multicolor pattern, such as in a formal Japanese kimono. In using them, think more about the overall impression than whether the colors do well together. For instance, in Japanese classical drama (Kubuki), the colors in example 323 are sometimes used for the costume of young girls (and, at the same time, the city of Tokyo uses example 331 for its buses).

38

331 Y40 M10 / Y100 C80

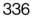

336 Y50 C10 / Y30 C100

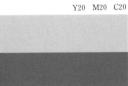

332 M50 / M100 C50

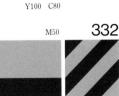

337 Y20 M20 C20 / M50 C100

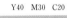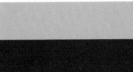

333 Y50 M10 / Y100 M100 C20

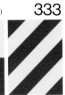

338 Y40 M30 C20 / M100 C30

334 Y50 M40 / Y30 M90 C100

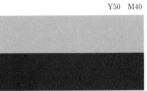

339 Y30 M20 C20 / Y50 M100

335 Y50 C10 / Y10 M90 C100

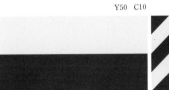

340 Y30 C50 / M90 C80

M100 M100

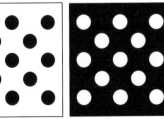

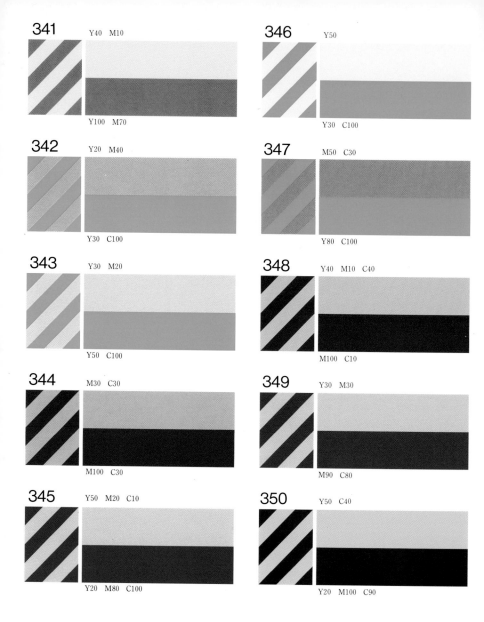

341 Y40 M10
Y100 M70

346 Y50
Y30 C100

342 Y20 M40
Y30 C100

347 M50 C30
Y80 C100

343 Y30 M20
Y50 C100

348 Y40 M10 C40
M100 C10

344 M30 C30
M100 C30

349 Y30 M30
M90 C80

345 Y50 M20 C10
Y20 M80 C100

350 Y50 C40
Y20 M100 C90

Bright with Vivid Colors (continued)

Y20 C30 **351**

Y100 M70

Y50 M20 **356**

M40 C100

Y50 M10 **352**

Y100 C100

Y40 M10 C50 **357**

M60 C100

Y30 M10 C50 **353**

Y50 M100

Y30 M20 C10 **358**

Y100 M100 C20

M40 **354**

M100 C100

Y40 M20 C50 **359**

Y80 M100

M30 C50 **355**

Y10 M90 C100

Y50 C30 **360**

M100 C50

C100

C100

41

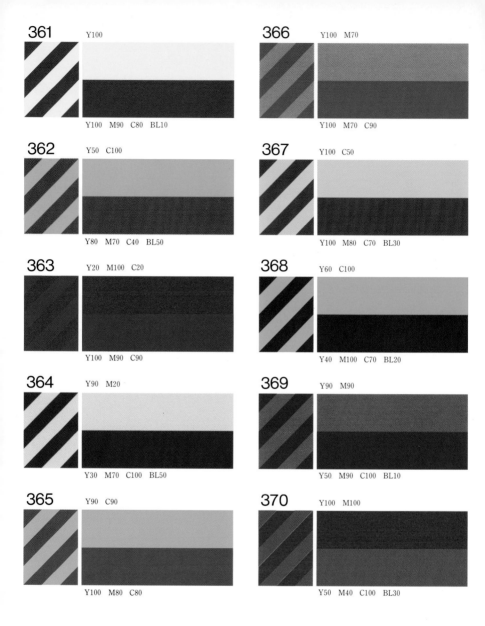

361 Y100

Y100 M90 C80 BL10

362 Y50 C100

Y80 M70 C40 BL50

363 Y20 M100 C20

Y100 M90 C90

364 Y90 M20

Y30 M70 C100 BL50

365 Y90 C90

Y100 M80 C80

366 Y100 M70

Y100 M70 C90

367 Y100 C50

Y100 M80 C70 BL30

368 Y60 C100

Y40 M100 C70 BL20

369 Y90 M90

Y50 M90 C100 BL10

370 Y100 M100

Y50 M40 C100 BL30

Vivid with Concentrated Colors

At either side of the color wheel, the differences among colors become increasingly fine. Darker colors tend to be among the browns, purples, blues, greens, and grays. Pairing a dark color with a brilliant color serves to emphasize the brilliant color as well as the contrast.

These color schemes are comparatively easy to arrange and make a strong graphic statement.

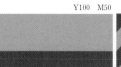

Y100 M50 **371**

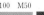

Y80 M60 C40 BL50

Y70 C100 **376**

Y60 M60 C90 BL10

Y70 M100 **372**

Y80 M100 C50 BL10

Y30 C100 **377**

Y60 M100 C100

Y100 M80 **373**

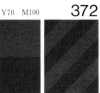

Y30 M70 C100 BL50

Y10 M100 **378**

M70 C100 BL50

C100 **374**

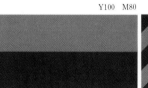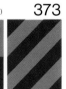

Y50 M50 C40 BL90

M50 C100 **379**

Y20 M90 C80 BL50

Y100 C100 **375**

Y50 M100 C80

Y30 M100 **380**

Y100 M90 C80 BL20

Y50 C100

Y50 C100

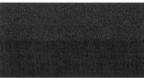

43

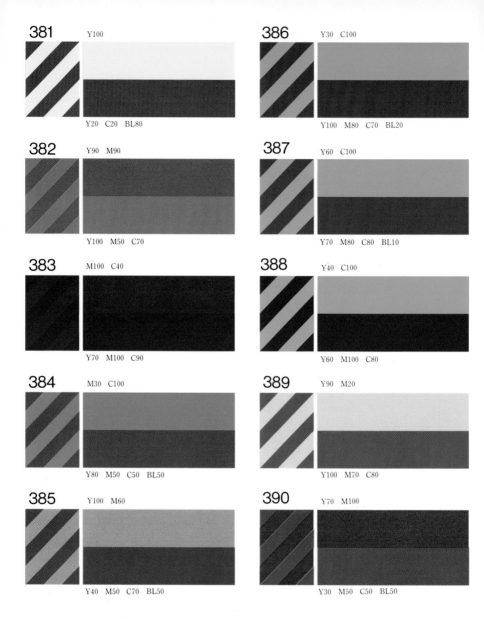

381 Y100

Y20 C20 BL80

382 Y90 M90

Y100 M50 C70

383 M100 C40

Y70 M100 C90

384 M30 C100

Y80 M50 C50 BL50

385 Y100 M60

Y40 M50 C70 BL50

386 Y30 C100

Y100 M80 C70 BL20

387 Y60 C100

Y70 M80 C80 BL10

388 Y40 C100

Y60 M100 C80

389 Y90 M20

Y100 M70 C80

390 Y70 M100

Y30 M50 C50 BL50

Vivid with Concentrated Colors
(continued)

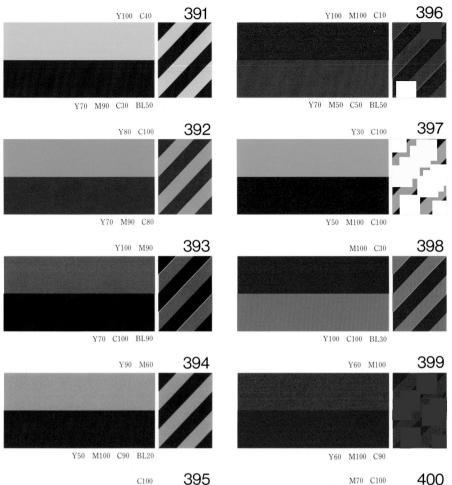

Y100 C40 **391**

Y70 M90 C30 BL50

Y80 C100 **392**

Y70 M90 C80

Y100 M90 **393**

Y70 C100 BL90

Y90 M60 **394**

Y50 M100 C90 BL20

C100 **395**

Y90 M100 C70 BL20

Y100 M100 C10 **396**

Y70 M50 C50 BL50

Y30 C100 **397**

Y50 M100 C100

M100 C30 **398**

Y100 C100 BL30

Y60 M100 **399**

Y60 M100 C90

M70 C100 **400**

Y70 M90 C80 BL50

Y100 M50

Y100 M50

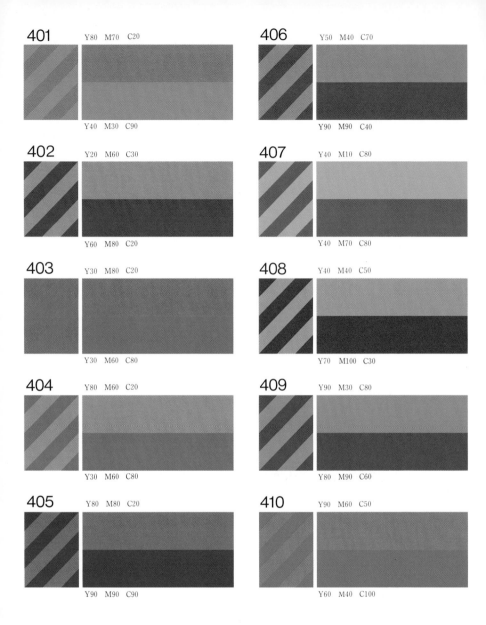

401 Y80 M70 C20 / Y40 M30 C90

406 Y50 M40 C70 / Y90 M90 C40

402 Y20 M60 C30 / Y60 M80 C20

407 Y40 M10 C80 / Y40 M70 C80

403 Y30 M80 C20 / Y30 M60 C80

408 Y40 M40 C50 / Y70 M100 C30

404 Y80 M60 C20 / Y30 M60 C80

409 Y90 M30 C80 / Y80 M90 C60

405 Y80 M80 C20 / Y90 M90 C90

410 Y90 M60 C50 / Y60 M40 C100

Medium Colors

Randomly selected, these slightly dull colors are combined with brighter, more intense colors for traditional effect and crispness. In example 401, a red–blue color scheme, you could easily substitute a brown for the burnt orange.

These colors can evoke moods, sounds, memories, eras, and seasons just as powerfully and immediately as brighter colors.

Y80 M50 C30 **411**

Y40 M30 C90

Y50 C90 **416**

Y90 M90 C80

Y40 M30 C50 **412**

Y60 M90 C70

Y50 C90 **417**

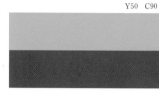

Y50 M80 C90

Y30 M70 C50 **413**

Y50 M60 C100

Y30 M90 C20 **418**

Y100 M70 C80

Y50 M90 C40 **414**

Y90 M60 C80

Y30 M70 C40 **419**

Y80 M50 C100

Y90 M50 C40 **415**

Y30 M60 C100

Y60 M50 C70 **420**

Y50 M80 C90

Y100 M70 C30 Y100 M70 C30

47

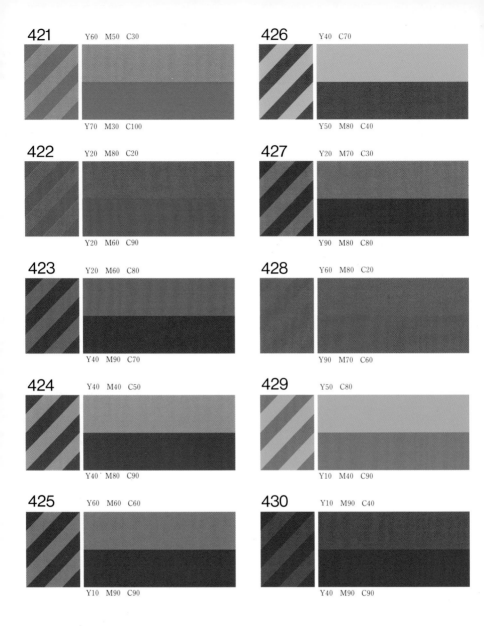

421 Y60 M50 C30

Y70 M30 C100

426 Y40 C70

Y50 M80 C40

422 Y20 M80 C20

Y20 M60 C90

427 Y20 M70 C30

Y90 M80 C80

423 Y20 M60 C80

Y40 M90 C70

428 Y60 M80 C20

Y90 M70 C60

424 Y40 M40 C50

Y40 M80 C90

429 Y50 C80

Y10 M40 C90

425 Y60 M60 C60

Y10 M90 C90

430 Y10 M90 C40

Y40 M90 C90

Medium Colors (continued)

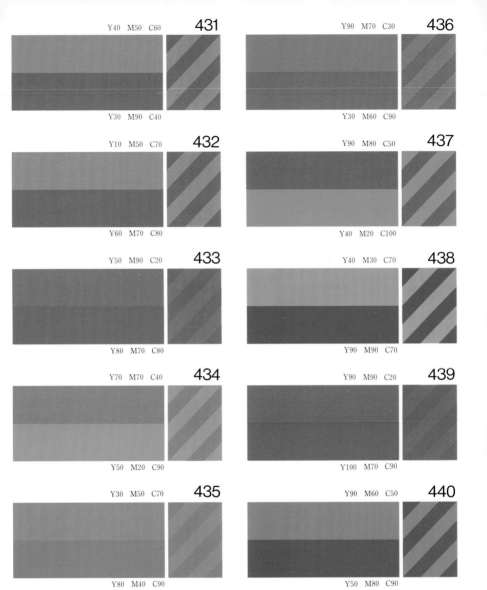

Y40 M50 C60 **431**

Y30 M90 C40

Y90 M70 C30 **436**

Y30 M60 C90

Y10 M50 C70 **432**

Y60 M70 C80

Y90 M80 C50 **437**

Y40 M20 C100

Y50 M90 C20 **433**

Y80 M70 C80

Y40 M30 C70 **438**

Y90 M90 C70

Y70 M70 C40 **434**

Y50 M20 C90

Y90 M90 C20 **439**

Y100 M70 C90

Y30 M50 C70 **435**

Y80 M40 C90

Y90 M60 C50 **440**

Y50 M80 C90

M90 C50

M90 C50

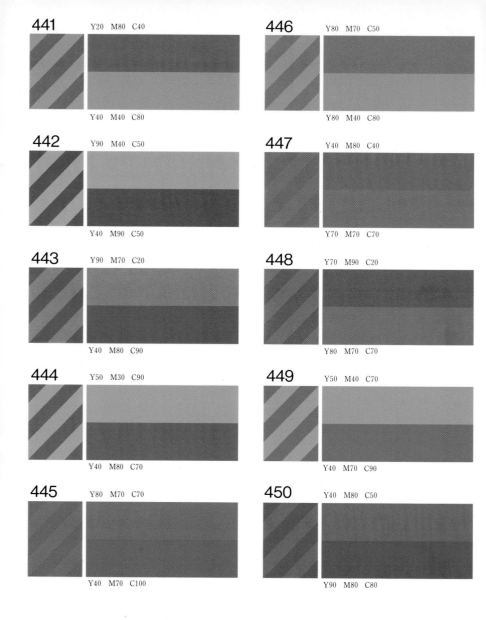

441 Y20 M80 C40
Y40 M40 C80

446 Y80 M70 C50
Y80 M40 C80

442 Y90 M40 C50
Y40 M90 C50

447 Y40 M80 C40
Y70 M70 C70

443 Y90 M70 C20
Y40 M80 C90

448 Y70 M90 C20
Y80 M70 C70

444 Y50 M30 C90
Y40 M80 C70

449 Y50 M40 C70
Y40 M70 C90

445 Y80 M70 C70
Y40 M70 C100

450 Y40 M80 C50
Y90 M80 C80

Medium Colors (continued)

Y20 M60 C10 **451**

Y30 M80 C90

Y40 M30 C80 **456**

Y80 M70 C70

Y80 M80 C30 **452**

Y90 M90 C60

Y70 M70 C10 **457**

Y80 M90 C20

Y10 M70 G60 **453**
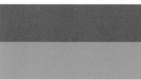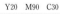

Y60 M60 C80

Y20 M90 C30 **458**

Y50 M30 C100

Y50 M30 C90 **454**

Y40 M60 C90

Y50 M30 C50 **459**

Y30 M80 C90

Y70 M90 C40 **455**
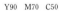

Y50 M90 C90

Y90 M70 C50 **460**

Y60 M50 C100

M70 C90 M70 C 90
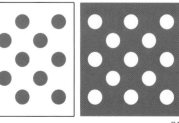

51

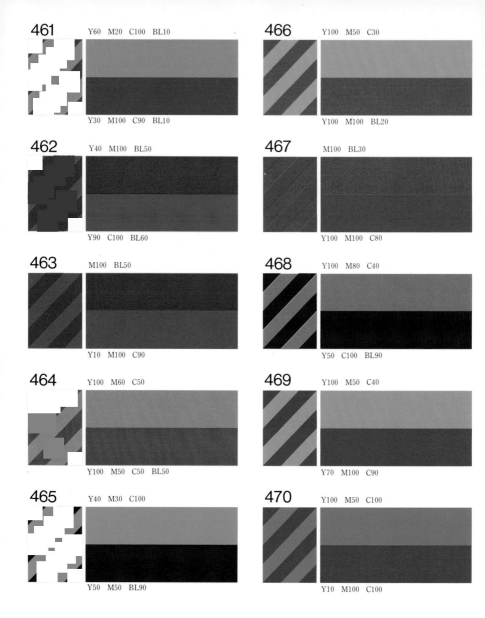

461 Y60 M20 C100 BL10

Y30 M100 C90 BL10

462 Y40 M100 BL50

Y90 C100 BL60

463 M100 BL50

Y10 M100 C90

464 Y100 M60 C50

Y100 M50 C50 BL50

465 Y40 M30 C100

Y50 M50 BL90

466 Y100 M50 C30

Y100 M100 BL20

467 M100 BL30

Y100 M100 C80

468 Y100 M80 C40

Y50 C100 BL90

469 Y100 M50 C40

Y70 M100 C90

470 Y100 M50 C100

Y10 M100 C100

Deep Colors

Colors in this category have a rich, luxurious quality which we seem to appreciate most in autumn. Analogies in material would be velvet or fine wool. They might be appropriate to suggest maturity, haute couture, country life, handmade sweaters, mystery, or romance.

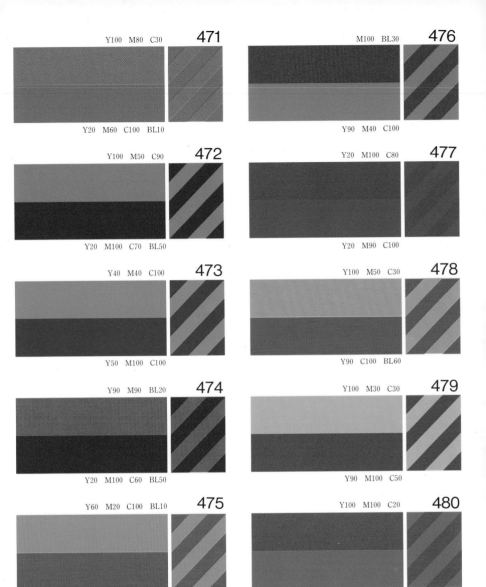

Y100 M80 C30 **471**

Y20 M60 C100 BL10

M100 BL30 **476**

Y90 M40 C100

Y100 M50 C90 **472**

Y20 M100 C70 BL50

Y20 M100 C80 **477**

Y20 M90 C100

Y40 M40 C100 **473**

Y50 M100 C100

Y100 M50 C30 **478**

Y90 C100 BL60

Y90 M90 BL20 **474**

Y20 M100 C60 BL50

Y100 M30 C30 **479**

Y90 M100 C50

Y60 M20 C100 BL10 **475**

C100 BL60

Y100 M100 C20 **480**

Y100 M60 C100

Y20 M90 C100

Y20 M90 C100

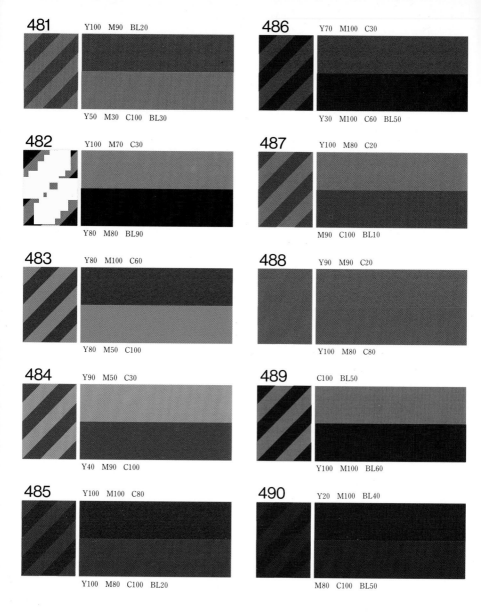

481 Y100 M90 BL20

Y50 M30 C100 BL30

482 Y100 M70 C30

Y80 M80 BL90

483 Y80 M100 C60

Y80 M50 C100

484 Y90 M50 C30

Y40 M90 C100

485 Y100 M100 C80

Y100 M80 C100 BL20

486 Y70 M100 C30

Y30 M100 C60 BL50

487 Y100 M80 C20

M90 C100 BL10

488 Y90 M90 C20

Y100 M80 C80

489 C100 BL50

Y100 M100 BL60

490 Y20 M100 BL40

M80 C100 BL50

Deep Colors (continued)

54

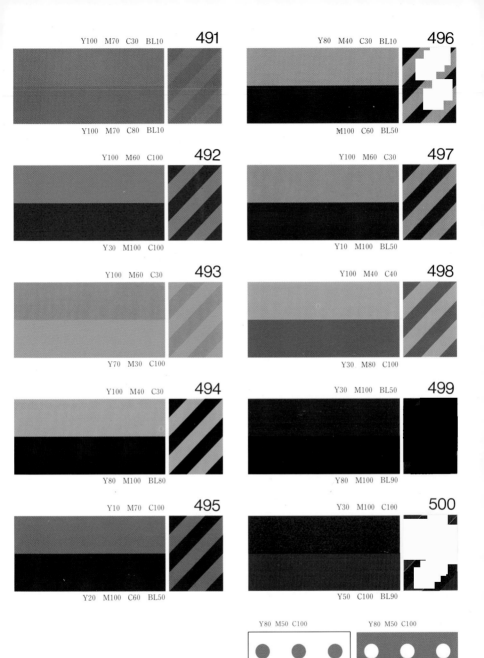

Y100　M70　C30　BL10　**491**

Y100　M70　C80　BL10

Y100　M60　C100　**492**

Y30　M100　C100

Y100　M60　C30　**493**

Y70　M30　C100

Y100　M40　C30　**494**

Y80　M100　BL80

Y10　M70　C100　**495**

Y20　M100　C60　BL50

Y80　M40　C30　BL10　**496**

M100　C60　BL50

Y100　M60　C30　**497**

Y10　M100　BL50

Y100　M40　C40　**498**

Y30　M80　C100

Y30　M100　BL50　**499**

Y80　M100　BL90

Y30　M100　C100　**500**

Y50　C100　BL90

Y80　M50　C100

Y80　M50　C100

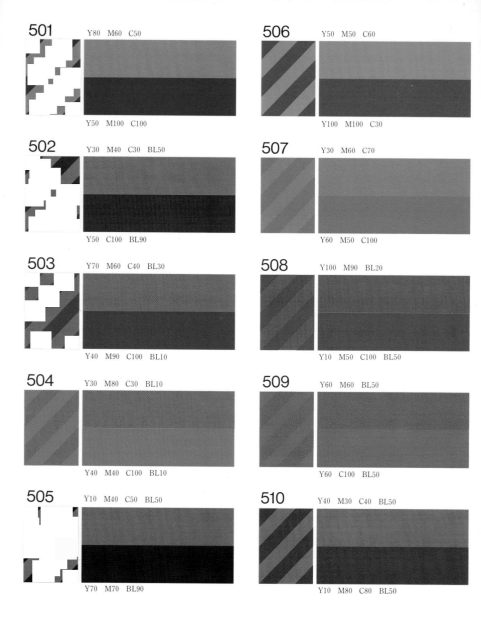

501 Y80 M60 C50 / Y50 M100 C100

502 Y30 M40 C30 BL50 / Y50 C100 BL90

503 Y70 M60 C40 BL30 / Y40 M90 C100 BL10

504 Y30 M80 C30 BL10 / Y40 M40 C100 BL10

505 Y10 M40 C50 BL50 / Y70 M70 BL90

506 Y50 M50 C60 / Y100 M100 C30

507 Y30 M60 C70 / Y60 M50 C100

508 Y100 M90 BL20 / Y10 M50 C100 BL50

509 Y60 M60 BL50 / Y60 C100 BL50

510 Y40 M30 C40 BL50 / Y10 M80 C80 BL50

Concentrated Colors

Both dark and a little dull, these colors
are fall and winter fashion shades. They
are rich, subdued, and elegant.

Y70 M70 C40 **511**

Y100 M80 C90

Y40 M70 C30 **512**

M80 C100 BL50

Y30 M40 C30 BL50 **513**

Y10 M100 BL50

Y100 M90 BL20 **514**

Y80 M90 C80 BL20

Y60 M50 C100 **515**

Y90 M100 C80

Y20 M80 C80 **516**

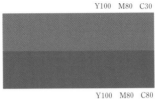

Y50 M60 C100

Y100 M80 C30 **517**

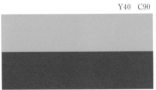

Y100 M80 C80

Y40 C90 **518**

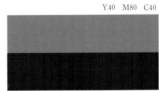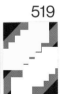

Y50 M100 C80

Y40 M80 C40 **519**

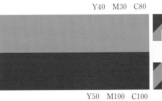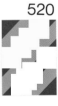

Y80 M80 BL90

Y40 M30 C80 **520**

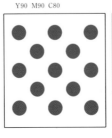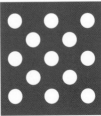

Y50 M100 C100

Y90 M90 C80 Y90 M90 C80

57

521 Y50 M50 C70

Y100 M100 C90

522 Y30 M20 C80

Y100 M80 C80 BL20

523 Y80 M60 C50

Y90 M60 C100

524 Y50 M50 C70

Y20 M100 C60 BL50

525 Y50 M30 C30 BL50

Y50 C100 BL90

526 Y10 C10 BL60

Y30 M100 C80 BL30

527 Y100 M50 C60 BL10

Y100 M80 C80 BL10

528 Y30 M60 C50 BL10

Y40 M90 C100 BL10

529 Y70 M80 C40

Y20 M60 C100 BL50

530 Y50 M20 C30 BL50

Y20 M100 C30 BL50

Concentrated Colors (continued)

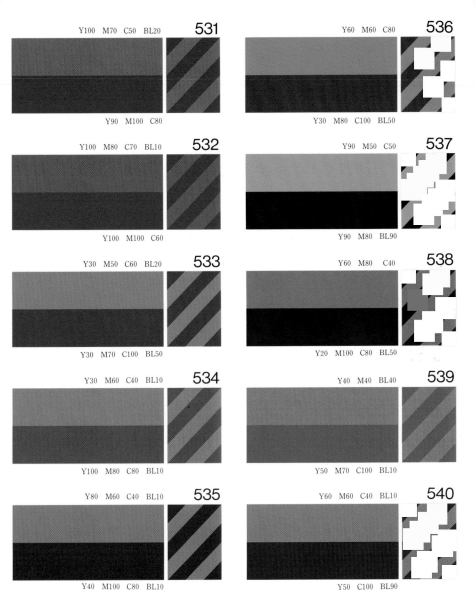

Y100 M70 C50 BL20 **531**

Y90 M100 C80

Y100 M80 C70 BL10 **532**

Y100 M100 C60

Y30 M50 C60 BL20 **533**

Y30 M70 C100 BL50

Y30 M60 C40 BL10 **534**

Y100 M80 C80 BL10

Y80 M60 C40 BL10 **535**

Y40 M100 C80 BL10

Y60 M60 C80 **536**

Y30 M80 C100 BL50

Y90 M50 C50 **537**

Y90 M80 BL90

Y60 M80 C40 **538**

Y20 M100 C80 BL50

Y40 M40 BL40 **539**

Y50 M70 C100 BL10

Y60 M60 C40 BL10 **540**

Y50 C100 BL90

Y60 M90 C80

Y60 M90 C80

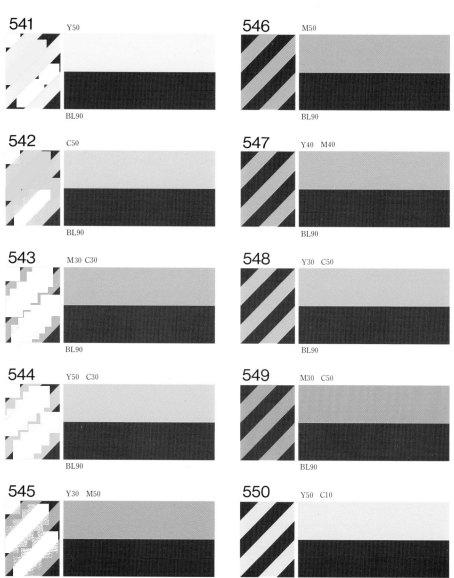

541 Y50 / BL90

542 C50 / BL90

543 M30 C30 / BL90

544 Y50 C30 / BL90

545 Y30 M50 / BL90

546 M50 / BL90

547 Y40 M40 / BL90

548 Y30 C50 / BL90

549 M30 C50 / BL90

550 Y50 C10 / BL90

Charcoal Gray

Called *sumi-iro* in Japanese, this gray is very close to black but creates a different tension. Its sensitive, sophisticated quality is well suited to formal wear. Contrasted here with bright colors, it can also create a soft and modern look. Use this gray when black would be too strong.

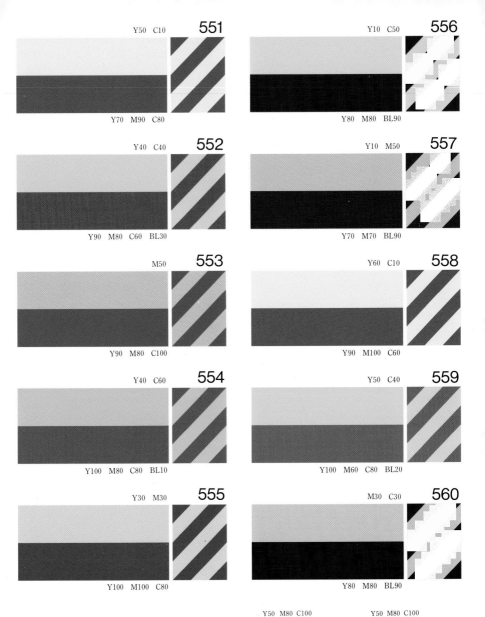

Y50 C10 **551**	Y10 C50 **556**
Y70 M90 C80	Y80 M80 BL90
Y40 C40 **552**	Y10 M50 **557**
Y90 M80 C60 BL30	Y70 M70 BL90
M50 **553**	Y60 C10 **558**
Y90 M80 C100	Y90 M100 C60
Y40 C60 **554**	Y50 C40 **559**
Y100 M80 C80 BL10	Y100 M60 C80 BL20
Y30 M30 **555**	M30 C30 **560**
Y100 M100 C80	Y80 M80 BL90

Bright with Concentrated Colors (1)
These color schemes demonstrate accentuated contrast.

Y50 M80 C100 Y50 M80 C100

61

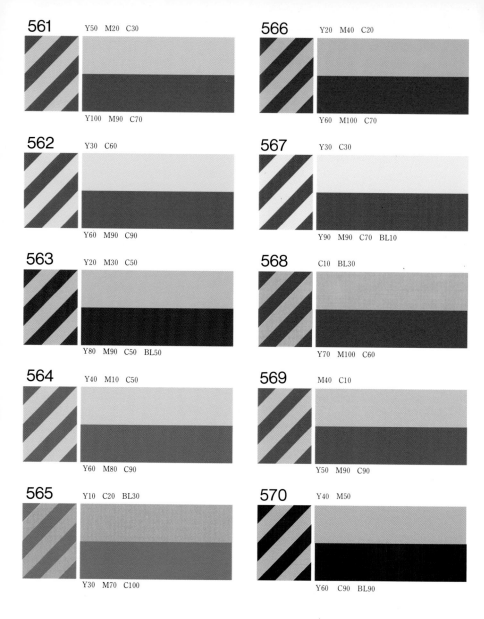

561 Y50 M20 C30

Y100 M90 C70

566 Y20 M40 C20

Y60 M100 C70

562 Y30 C60

Y60 M90 C90

567 Y30 C30

Y90 M90 C70 BL10

563 Y20 M30 C50

Y80 M90 C50 BL50

568 C10 BL30

Y70 M100 C60

564 Y40 M10 C50

Y60 M80 C90

569 M40 C10

Y50 M90 C90

565 Y10 C20 BL30

Y30 M70 C100

570 Y40 M50

Y60 C90 BL90

Bright with Concentrated Colors (1)
(continued)

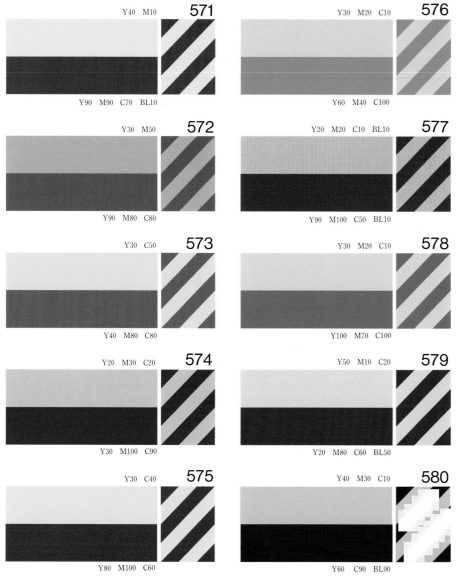

Y40 M10 **571**
Y90 M90 C70 BL10

Y30 M20 C10 **576**
Y60 M40 C100

Y30 M50 **572**
Y90 M80 C80

Y20 M20 C10 BL10 **577**
Y90 M100 C50 BL10

Y30 C50 **573**
Y40 M80 C80

Y30 M20 C10 **578**
Y100 M70 C100

Y20 M30 C20 **574**
Y30 M100 C90

Y50 M10 C20 **579**
Y20 M80 C60 BL50

Y30 C40 **575**
Y80 M100 C60

Y40 M30 C10 **580**
Y60 C90 BL90

Y100 M60 C80

Y100 M60 C80

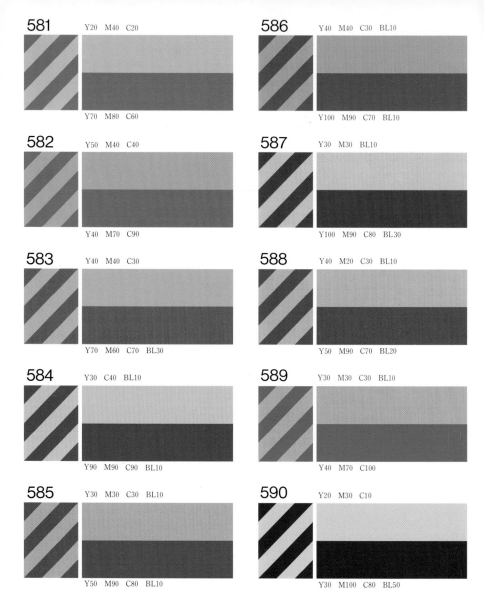

581 Y20 M40 C20

Y70 M80 C60

582 Y50 M40 C40

Y40 M70 C90

583 Y40 M40 C30

Y70 M60 C70 BL30

584 Y30 C40 BL10

Y90 M90 C90 BL10

585 Y30 M30 C30 BL10

Y50 M90 C80 BL10

586 Y40 M40 C30 BL10

Y100 M90 C70 BL10

587 Y30 M30 BL10

Y100 M90 C80 BL30

588 Y40 M20 C30 BL10

Y50 M90 C70 BL20

589 Y30 M30 C30 BL10

Y40 M70 C100

590 Y20 M30 C10

Y30 M100 C80 BL50

Bright with Concentrated Colors (2)

These color schemes contrast a dark color with a subdued neutral color. On page 64 are conservative shades and on page 65, lighter colors. These colors seem quiet, sedate, and elegant.

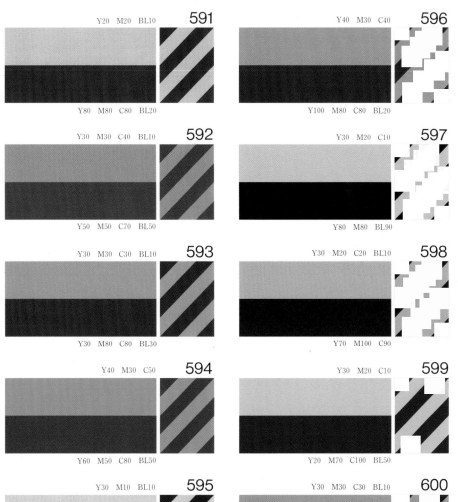

Y20 M20 BL10 **591**
Y80 M80 C80 BL20

Y40 M30 C40 **596**
Y100 M80 C80 BL20

Y30 M30 C40 BL10 **592**
Y50 M50 C70 BL50

Y30 M20 C10 **597**
Y80 M80 BL90

Y30 M30 C30 BL10 **593**
Y30 M80 C80 BL30

Y30 M20 C20 BL10 **598**
Y70 M100 C90

Y40 M30 C50 **594**
Y60 M50 C80 BL50

Y30 M20 C10 **599**
Y20 M70 C100 BL50

Y30 M10 BL10 **595**
Y100 M90 C80 BL30

Y30 M30 C30 BL10 **600**
Y60 C100 BL90

Y80 M100 C70

Y80 M100 C70

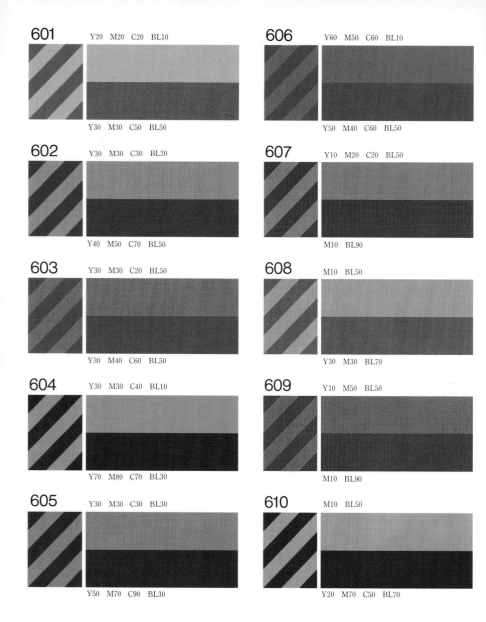

601 Y20 M20 C20 BL10

Y30 M30 C50 BL50

602 Y30 M30 C30 BL20

Y40 M50 C70 BL50

603 Y30 M30 C20 BL50

Y30 M40 C60 BL50

604 Y30 M30 C40 BL10

Y70 M80 C70 BL30

605 Y30 M30 C30 BL30

Y50 M70 C90 BL30

606 Y60 M50 C60 BL10

Y50 M40 C60 BL50

607 Y10 M20 C20 BL50

M10 BL90

608 M10 BL50

Y30 M30 BL70

609 Y10 M50 BL50

M10 BL90

610 M10 BL50

Y20 M70 C50 BL70

Subdued Colors

The colors on these pages have been greatly suppressed. Their grayish tones are not as easy to achieve as they appear. Two subdued but contrasting colors have been paired to bring out the colors even more strongly; for a more subdued effect, choose two related colors. While these are not youthful colors, their subtle dark contrasts could be used for summer fashions. These colors can be very satisfying. Pause a minute and consider the applications of such combinations as examples 628, 629, 633, or 640.

611

BL70

Y50 M60 C60 BL50

616

Y20 C40 BL50

Y50 M40 C60 BL50

612

Y30 M10 C30 BL50

Y30 M50 C70 BL50

617

M10 BL70

Y30 M60 C70 BL50

613

Y30 M30 C20 BL50

BL90

618

C10 BL70

Y50 M40 C70 BL50

614

M10 C10 BL50

Y40 M40 C70 BL50

619

Y30 M40 C60 BL50

Y30 M70 C70 BL50

615

Y20 M30 C50 BL50

Y50 M50 C80 BL60

620

Y40 M30 C20 BL50

Y60 M80 C60 BL60

BL100
Y50 M30 C70

Y50 M30 C70

67

621 Y60 M60 C70

Y60 M80 C80

622 Y40 M40 C60

Y50 M50 C50 BL40

623 Y60 M70 C60

Y20 M50 C60 BL50

624 Y40 M50 C70

Y60 M100 BL90

625 Y50 M50 C60

Y60 M90 C60 BL50

626 Y20 C20 BL50

Y20 M60 C60 BL50

627 C40 BL50

Y20 M20 C30 BL80

628 Y60 M50 C80

Y30 M60 C60 BL50

629 Y50 M50 C70

Y30 M70 C40 BL50

630 Y40 M40 C40 BL50

Y50 M100 BL90

Subdued Colors (continued)

68

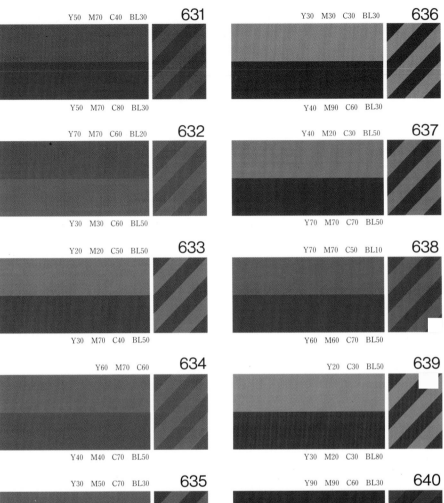

Y50 M70 C40 BL30 **631**

Y50 M70 C80 BL30

Y30 M30 C30 BL30 **636**

Y40 M90 C60 BL30

Y70 M70 C60 BL20 **632**

Y30 M30 C60 BL50

Y40 M20 C30 BL50 **637**

Y70 M70 C70 BL50

Y20 M20 C50 BL50 **633**

Y30 M70 C40 BL50

Y70 M70 C50 BL10 **638**

Y60 M60 C70 BL50

Y60 M70 C60 **634**

Y40 M40 C70 BL50

Y20 C30 BL50 **639**

Y30 M20 C30 BL80

Y30 M50 C70 BL30 **635**

Y30 M70 C60 BL50

Y90 M90 C60 BL30 **640**

Y60 M50 C80 BL50

M60 M60 C70

BL100
Y60 M60 C70

641 Y50 M60 C50 BL60

Y60 M90 C60 BL50

646 Y20 M30 C50 BL60

Y20 M40 C100 BL80

642 Y90 M90 C70 BL20

Y60 C100 BL90

647 Y70 M90 C60 BL50

Y50 M50 C70 BL70

643 Y50 M30 C50 BL70

Y70 M20 C100 BL90

648 Y40 M30 C70 BL70

Y50 M90 C30 BL90

644 Y50 M90 C50 BL70

Y30 M40 C30 BL90

649 Y20 M50 C60 BL60

Y30 M30 C30 BL90

645 Y30 M60 C30 BL60

Y30 M90 BL90

650 Y20 M60 C60 BL60

Y20 M40 C100 BL80

Dark Colors
The combination of two dark colors creates a beautiful, rich fall/winter color scheme. The colors are orderly, serious, refined, and extremely handsome.

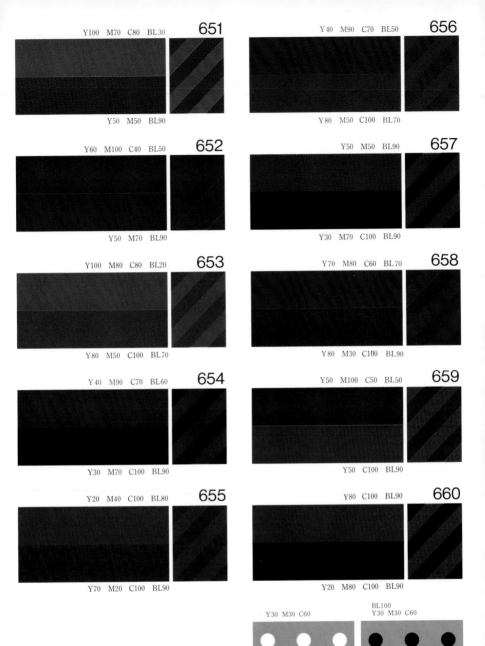

Y100 M70 C80 BL30 **651**

Y50 M50 BL90

Y40 M90 C70 BL50 **656**

Y80 M50 C100 BL70

Y60 M100 C40 BL50 **652**

Y50 M70 BL90

Y50 M50 BL90 **657**

Y30 M70 C100 BL90

Y100 M80 C80 BL20 **653**

Y80 M50 C100 BL70

Y70 M80 C60 BL70 **658**

Y80 M30 C100 BL90

Y40 M90 C70 BL60 **654**

Y30 M70 C100 BL90

Y50 M100 C50 BL50 **659**

Y50 C100 BL90

Y20 M40 C100 BL80 **655**

Y70 M20 C100 BL90

Y80 C100 BL90 **660**

Y20 M80 C100 BL90

Y30 M30 C60

BL100
Y30 M30 C60

71

661 Y50 M50 C50 BL100
Y100

662 Y50 M50 C50 BL100
Y100 C30

663 Y50 M50 C50 BL100
Y100 C70

664 Y50 M50 C50 BL100
Y100 C100

665 Y50 M50 C50 BL100
Y50 C100

666 Y50 M50 C50 BL100
Y30 C100

667 Y50 M50 C50 BL100
C100

668 Y50 M50 C50 BL100
M30 C100

669 Y50 M50 C50 BL100
M70 C100

670 Y50 M50 C50 BL100
M100 C100

Black with Vivid Colors

Black has chameleon characteristics, depending on the material used; its tones will vary from reddish black to bluish black and look entirely different on velvet and cotton. In fashion it's essential to consider the fabric, the color tone, and the design when using black. "School bus yellow" and black, as in example 680, is considered to be the most visible color combination that we use.

72

Y50 M50 C50 BL100 **671**
M100 C70

Y50 M50 C50 BL100 **672**
M100 C50

Y50 M50 C50 BL100 **673**
M100 C30

Y50 M50 C50 BL100 **674**
M100

Y50 M50 C50 BL100 **675**
Y30 M100

Y50 M50 C50 BL100 **676**
Y50 M100

Y50 M50 C50 BL100 **677**
Y100 M100

Y50 M50 C50 BL100 **678**
Y100 M70

Y50 M50 C50 BL100 **679**
Y100 M50

Y50 M50 C50 BL100 **680**
Y100 M30

BL100
Y10 M100

BL100
Y30 C100

681 Y50 M50 C50 BL100 / Y90 M40 C30

682 Y50 M50 C50 BL100 / Y100 M60 C70 BL10

683 Y50 M50 C50 BL100 / Y90 C100 BL40

684 Y50 M50 C50 BL100 / Y50 C100 BL40

685 Y50 M50 C50 BL100 / Y50 M60 C100

686 Y50 M50 C50 BL100 / Y50 M100 C70

687 Y50 M50 C50 BL100 / Y70 M100 C60

688 Y50 M50 C50 BL100 / Y60 M100 C40

689 Y50 M50 C50 BL100 / Y70 M70 C40

690 Y50 M50 C50 BL100 / Y100 M70 C30

Black with Concentrated Colors

By darkening the color paired with black, the color scheme gains stability. Black is a basic fashion color that imparts calmness and richness to any color scheme. Calmness, mystery, and maturity are suggested and reinforced by the use of black with certain colors.

74

Y50 M50 C50 BL100 **691**

Y100 M80 C80

Y50 M50 C50 BL100 **692**

Y80 C80 BL50

Y50 M50 C50 BL100 **693**

Y70 C100 BL80

Y50 M50 C50 BL100 **694**

Y60 C100 BL90

Y50 M50 C50 BL100 **695**

Y20 M40 C100 BL50

Y50 M50 C50 BL100 **696**

Y70 M100 C90

Y50 M50 C50 BL100 **697**

Y60 M100 C40 BL40

Y50 M50 C50 BL100 **698**

Y70 M100 BL50

Y50 M50 C50 BL100 **699**

Y90 M90 C80

Y50 M50 C50 BL100 **700**

Y50 M40 BL90

BL100
Y50 M100 C70

BL100
Y70 M50 C100

75

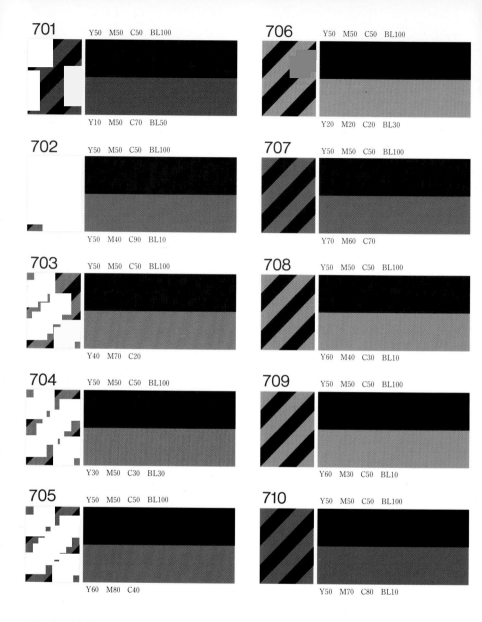

701 Y50 M50 C50 BL100

Y10 M50 C70 BL50

702 Y50 M50 C50 BL100

Y50 M40 C90 BL10

703 Y50 M50 C50 BL100

Y40 M70 C20

704 Y50 M50 C50 BL100

Y30 M50 C30 BL30

705 Y50 M50 C50 BL100

Y60 M80 C40

706 Y50 M50 C50 BL100

Y20 M20 C20 BL30

707 Y50 M50 C50 BL100

Y70 M60 C70

708 Y50 M50 C50 BL100

Y60 M40 C30 BL10

709 Y50 M50 C50 BL100

Y60 M30 C50 BL10

710 Y50 M50 C50 BL100

Y50 M70 C80 BL10

Black with Medium Colors

Black always intensifies the color it is paired with: in combination with a dull sober tone, it makes an agreeable, formal, stable color scheme. With some of these colors, black suggests art deco color motifs.

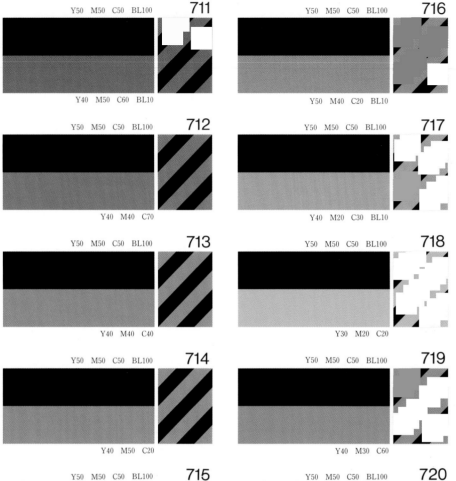

Y50 M50 C50 BL100 **711**

Y40 M50 C60 BL10

Y50 M50 C50 BL100 **716**

Y50 M40 C20 BL10

Y50 M50 C50 BL100 **712**

Y40 M40 C70

Y50 M50 C50 BL100 **717**

Y40 M20 C30 BL10

Y50 M50 C50 BL100 **713**

Y40 M40 C40

Y50 M50 C50 BL100 **718**

Y30 M20 C20

Y50 M50 C50 BL100 **714**

Y40 M50 C20

Y50 M50 C50 BL100 **719**

Y40 M30 C60

Y50 M50 C50 BL100 **715**

Y60 M70 C60

Y50 M50 C50 BL100 **720**

Y30 C40 BL50

BL100
Y40 M30 C40

BL100
Y40 M60 C20

77

721

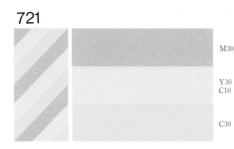

M30

Y30
C10

C30

725

Y30
C30

M30

M30
C30

722

Y30
M30

M30

Y30
C30

726

Y10
C30

Y50
C10

BL4

723

Y10
M30

Y30
M10

M30
C10

727

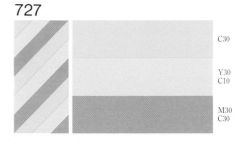

C30

Y30
C10

M30
C30

724

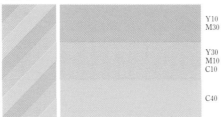

Y10
M30

Y30
M10
C10

C40

728

Y30
C30

Y30
M30

M30
C30

Pale Colors

It is important when working with these colors to strive for a feeling of unity. It is best to control the general tone and, in the case of similar colors, to choose ones with varying degrees of brightness.

729

Y30
BL10

Y40

Y30
M30

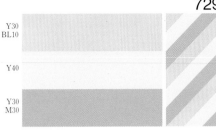

730

Y10
M30

Y30

C10
BL30

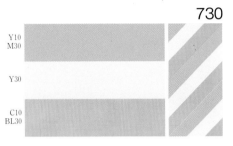

731

Y30
M10
C30

Y30
M10

Y10
M30
C30

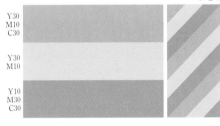

732

Y30
BL10

Y10
M30

BL40

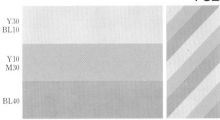

733

Y10
M30
C10

Y30
M10

Y30
M30
C30

734

Y10
M10
C30

Y30
C30

Y30
M30
C20

735

Y30
M30
C10

Y30
C10

Y20
M40
C30

736

C10
BL30

Y30

Y10
M30
C30

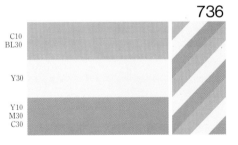

BL40
Y10 M30

BL40
Y10 C40

737

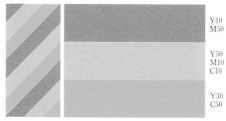

Y10
M50

Y50
M10
C10

Y30
C50

741

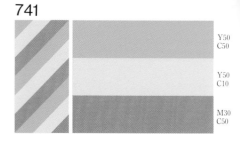

Y50
C50

Y50
C10

M30
C50

738

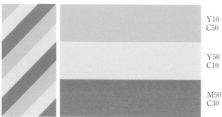

Y10
C50

Y50
C10

M50
C30

742

Y30
C60

Y50

BL50

739

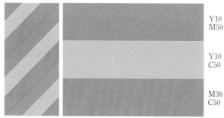

Y10
M50

Y10
C50

M30
C50

743

Y50
M20
C20

Y50
C10

Y50
M50

740

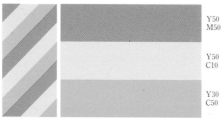

Y50
M50

Y50
C10

Y30
C50

744

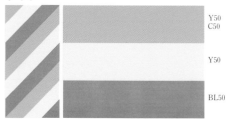

Y50
C50

Y50

BL50

Bright Colors

These sweet spring colors have the light-heartedness of an amusement park. Consider here not only the color combination but also the balance of brightness and brilliance of the overall color scheme.

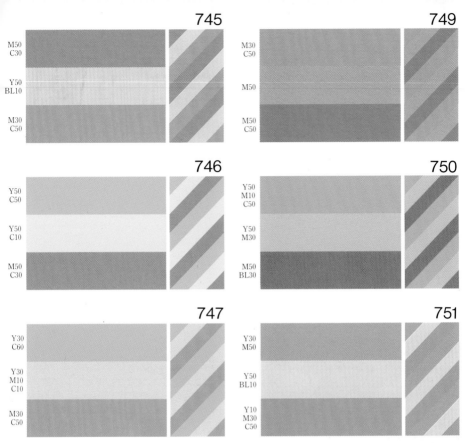

745

M50
C30

Y50
BL10

M30
C50

749

M30
C50

M50

M50
C50

746

Y50
C50

Y50
C10

M50
C30

750

Y50
M10
C50

Y50
M30

M50
BL30

747

Y30
C60

Y30
M10
C10

M30
C50

751

Y30
M50

Y50
BL10

Y10
M30
C50

748

Y30
M50

Y50

M50
C50

752

M50
C30

M50

M10
BL50

BL70
Y50 M10 C10

BL70
Y30 C50

753

Y50
C40

Y40

M30
BL30

757

Y60
M30
C30

Y60
M10
C10

Y30
M30
C60

754

M50
C10

Y30
BL10

C30
BL30

758

Y50
M50
C10

Y40
M10
C10

Y50
M40
C60

755

Y50
M50

Y50
M10
C10

C30
BL30

759

Y30
C60

Y50
M40
C10

Y40
M50
C60

756

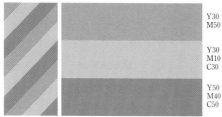

Y30
M50

Y30
M10
C30

Y50
M40
C50

760

Y10
M30
C50

Y50
BL10

M10
BL50

Bright Colors (continued)

82

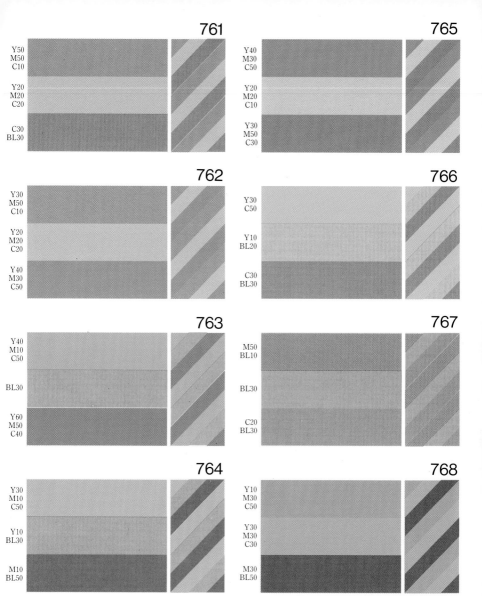

761

Y50
M50
C10

Y20
M20
C20

C30
BL30

765

Y40
M30
C50

Y20
M20
C10

Y30
M50
C30

762

Y30
M50
C10

Y20
M20
C20

Y40
M30
C50

766

Y30
C50

Y10
BL20

C30
BL30

763

Y40
M10
C50

BL30

Y60
M50
C40

767

M50
BL10

BL30

C20
BL30

764

Y30
M10
C50

Y10
BL30

M10
BL50

768

Y10
M30
C50

Y30
M30
C30

M30
BL50

Bright Subdued Colors

A modicum of brightness keeps even a
subdued color from seeming melancholy.
Control the brightness of the colors in
these combinations and use at least one
neutral tone. These colors suggest rococo
themes.

BL70
M50 C30

BL70
Y50 M50

83

769

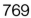
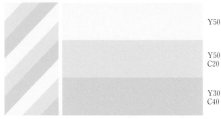

Y50

Y50
C20

Y30
C40

773

Y30
M10

Y30
M30

Y10
M50

770

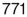
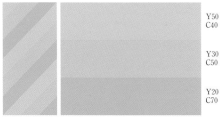

Y50
C40

Y30
C50

Y20
C70

774

M40

Y10
M50

Y60
M50

771

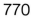
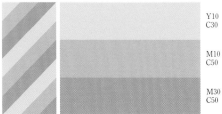

Y10
C30

M10
C50

M30
C50

775

Y50
M30

Y50
M50

Y10
M70

772

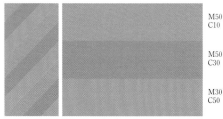

M50
C10

M50
C30

M30
C50

776

M40

M50
C30

M50
C50

Effects of Gradation

Combining gradations of the same color is a breeze: as long as the tones have an overall harmony and vary enough to avoid a monotone look, the color scheme will have colorful, deep tones. Springlike sherbet tones stand out well with this technique.

777

Y70
M10

Y70
C10

Y90
C40

778

Y70
C10

Y70
C30

Y30
C60

779

Y30
C50

Y30
C70

M30
C70

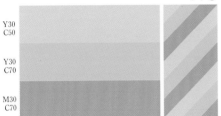

780

Y10
C70

M10
C70

M50
C70

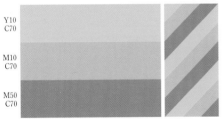

781

Y70
M30

M60

Y70
M70

782

Y70
M50

M50
C10

M60
C50

783

Y50
C60

C60

M30
C50

784

Y20
C70

M50
C50

M70
C70

BL100
Y30 M70

BL100
M30 C70

785

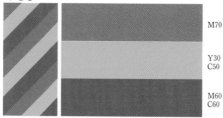

M70

Y30
C50

M60
C60

786

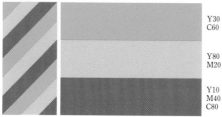

Y30
C60

Y80
M20

Y10
M40
C80

787

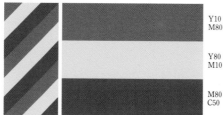

Y10
M80

Y80
M10

M80
C50

788

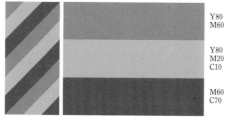

Y80
M60

Y80
M20
C10

M60
C70

789

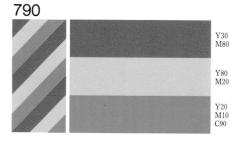

Y90
M60

M80

Y50
C90

790

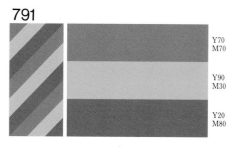

Y30
M80

Y80
M20

Y20
M10
C90

791

Y70
M70

Y90
M30

Y20
M80

792

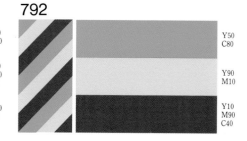

Y50
C80

Y90
M10

Y10
M90
C40

Bright Vivid Colors
Full of brilliance and light, the colors in
this group are often matched with white
for a healthy summer look. These colors
suggest energy, sporting activities, and
toys.

793
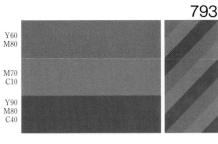

Y60
M80

M70
C10

Y90
M80
C40

797
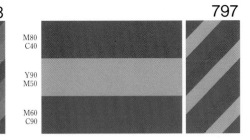

M80
C40

Y90
M50

M60
C90

794
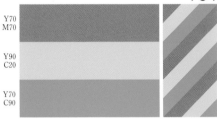

Y70
M70

Y90
C20

Y70
C90

798
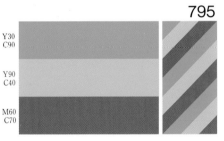

Y60
C90

M90

M50
C90

795
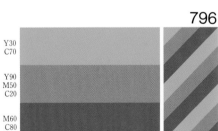

Y30
C90

Y90
C40

M60
C70

799
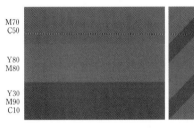

M70
C50

Y80
M80

Y30
M90
C10

796
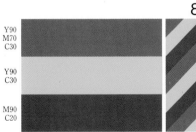

Y30
C70

Y90
M50
C20

M60
C80

800
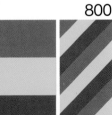

Y90
M70
C30

Y90
C30

M90
C20

BL100
Y70 M70

Y100 C50

87

801

Y10
M100

Y100
M10

M50
C100

805

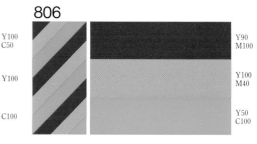

Y70
C100

Y100
M80

M90
C90

802

Y100
C50

Y100

C100

806

Y90
M100

Y100
M40

Y50
C100

803

Y50
C100

Y100
M50

M100
C70

807

Y100
C60

Y100
C20

Y80
M100

804

Y10
M100

Y100
M30

M100
C50

808

M50
C100

Y100
C30

M100
C90

More Vivid Colors
Bold use of these color schemes has a
very strong effect, because each of the
colors has very distinct and brilliant
characteristics.

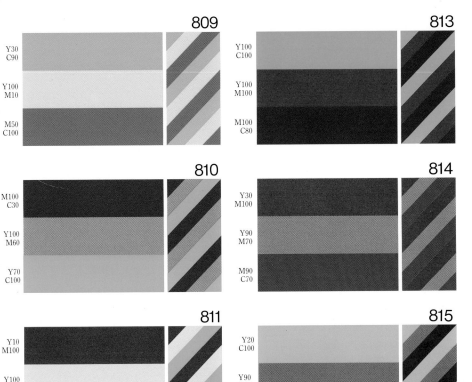

809

Y30
C90

Y100
M10

M50
C100

813

Y100
C100

Y100
M100

M100
C80

810

M100
C30

Y100
M60

Y70
C100

814

Y30
M100

Y90
M70

M90
C70

811

Y10
M100

Y100
C10

Y100
C100

815

Y20
C100

Y90
M80

M100
C100

812

Y60
C90

Y90
M60

Y10
C100

816

M100
C50

Y100
M30

M80
C100

BL100
M100 C30

BL100
Y30 C100

817

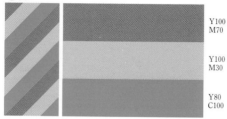

Y100
M70

Y100
M30

Y80
C100

821

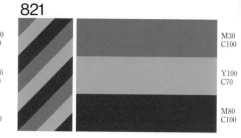

M30
C100

Y100
C70

M80
C100

818

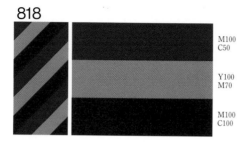

M100
C50

Y100
M70

M100
C100

822

M20
C100

Y100
M40

M100
C100

819

Y80
C100

Y100
M30

.M60
C100

823

M50
C100

Y70
C100

M100
C70

820

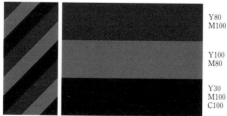

Y80
M100

Y100
M80

Y30
M100
C100

824

Y80
C100

M10
C100

M60
C100

More Vivid Colors (continued)

825
Y100
M70

Y100
M10

M100
C50

826
Y100
M100

Y100
M10

Y100
C100

827
Y90
M100

Y100
M10

M30
C100

828
M100
C30

Y100
M30

Y100
C100

829
Y10
M100
C30

Y90
C80

M70
C90

830
M100
C50

Y90
M100

Y10
M70
C100

831
Y70
C100

M100
C20

M100
C80

832
Y50
C100

Y10
M100

M70
C100

BL100
Y100 M20

BL100
Y100 M100

833

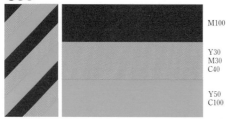

M100

Y30
M30
C40

Y50
C100

834

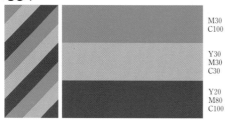

M30
C100

Y30
M30
C30

Y20
M80
C100

835

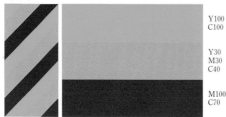

Y100
C100

Y30
M30
C40

M100
C70

836

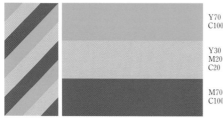

Y70
C100

Y30
M20
C20

M70
C100

837

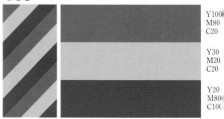

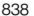

Y100
M10

Y40
M30
C40

Y100
M60

838

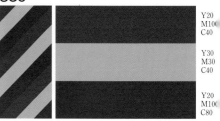

Y100
M80
C20

Y30
M20
C20

Y20
M80
C100

839

Y20
M100
C40

Y30
M30
C40

Y20
M100
C80

840

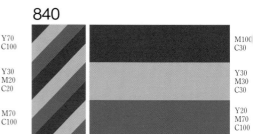

M100
C30

Y30
M30
C30

Y20
M70
C100

Vivid Colors plus a Neutral

One color scheme technique is to separate bright colors: colors are softened by adding a gray, emphasized by adding black. Here a beige (which has the same effect as gray) has been placed between two strong primary colors. The overall effect is muted and quite elegant.

Y100
M50

Y30
M30
C40

Y50
C100

Y100
C80

Y30
M20
C20

M70
C100

Y100
M100

Y40
M30
C40

M70
C100

Y80
M100

Y30
M30
C30

Y80
C100

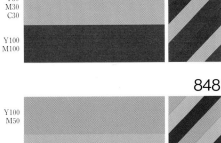

Y20
M100
C40

Y30
M30
C30

Y80
C100

M100

Y30
M30
C30

Y100
M100

Y20
M100
C80

Y30
M30
C30

Y20
M100
C100

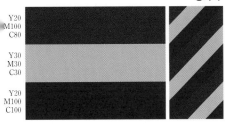

Y100
M50

Y30
M20
C40

M100
C70

BL100
Y80 C100

BL100
M70 C90

849

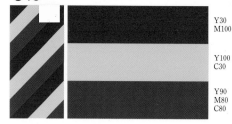

Y30
M100

Y100
C30

Y90
M80
C80

853

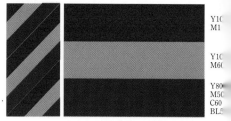

Y1(
M1

Y1(
M6(

Y80
M5C
C60
BL?

850

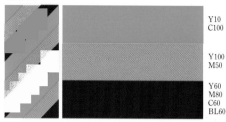

Y10
C100

Y100
M50

Y60
M80
C60
BL60

854

Y10(
M10

Y10(
M50

Y90
M90
C70
BL1

851

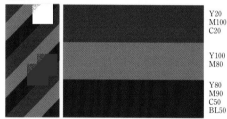

Y20
M100
C20

Y100
M80

Y80
M90
C50
BL50

855

Y100
M10C

Y100
M30

Y100
M70
C100

852

Y30
M100
C30

M100

Y100
M30
C100
BL50

856

Y70
C100

Y100
M10

Y90
M100
C50
BL50

Vivid Color plus
Concentrated Color (1)
The dark color at the bottom serves to tie
the three colors together. Browns, like
black and gray, are easy to use with
other colors. Among this group are many
hot, African colors in pleasing color
combinations.

857

Y100
M50

Y100

Y70
M80
C70
BL30

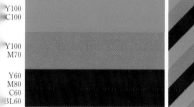

858

Y100
C100

Y100
M70

Y60
M80
C60
BL60

859

M50
C100

M100
C30

Y60
M80
C60
BL60

860

M100
C70

M100
C10

Y100
M70
C80
BL20

861

Y100
M100

Y100
C50

Y90
M90
C60
BL30

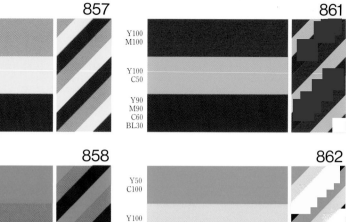

862

Y50
C100

Y100
M10

Y50
M50
BL90

863

Y10
M100

Y100
M50

Y70
M40
C100
BL50

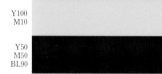

864

Y80
M30
C100

M100
C20

Y60
M100
BL90

Y90 M90 C80
Y100 M30

Y90 M90 C80
Y50 C80

865

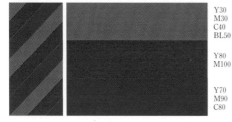

Y30
M30
C40
BL50

Y80
M100

Y70
M90
C80

869

Y90
M30
C90
BL2

Y10
M10

Y90
M90
C80

866

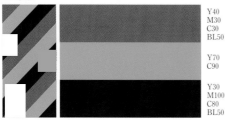

Y40
M30
C30
BL50

Y70
C90

Y30
M100
C80
BL50

870

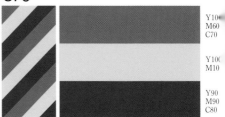

Y10
M60
C70

Y100
M10

Y90
M90
C80

867

Y100
M80
C70

Y100
M70

Y70
M70
C100

871

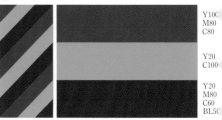

Y100
M80
C80

Y20
C100

Y20
M80
C60
BL50

868

M40
C50
BL60

M80
C70

Y70
C100
BL80

872

Y100
C100
BL30

Y100
M100

Y30
M100
C100
BL20

**Vivid Color plus
Concentrated Colors (2)**
In this contrast, two concentrated colors
are placed with one brilliant color. This
combination is hard to use because the
brighter color tends to be overpowering.
To control the effect, change the propor-
tions of the colors.

873

Y20
M40
C50
L50

Y50
C90

Y60
M90
C80

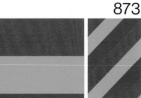

877

Y90
M60
C70

Y100
C40

Y100
M100
C70

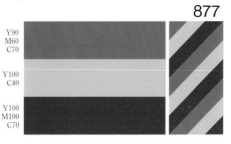

874

Y90
M70
C80

M90

M80
C90
BL50

878

Y90
M90
C70

M30
C100

Y80
M90
C50
BL50

875

Y20
M40
C50
BL50

Y100
M50

Y50
M50
BL90

879

Y30
M30
BL70

Y100
M10

Y100
M100
C60

876

Y90
M90
C80

Y70
C100

Y60
M100
C80

880

Y10
M70
C60
BL50

Y50
M100

Y40
M40
BL80

M100
Y100 M50 C100

M100
Y100 M70 C80

97

881

Y90
M80
C80

Y50
C90

Y40
M80
C90

882

Y60
M40
C80

Y100
M60

Y90
M90
C70
BL10

883

Y100
M70
C100

Y20
M100
C40

Y100
M90
C80

884

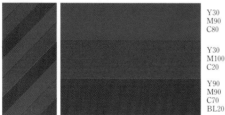

Y30
M90
C80

Y30
M100
C20

Y90
M90
C70
BL20

885

Y60
C100

Y90
M40

Y90
M80
C70

886

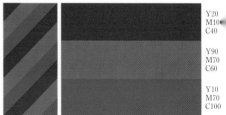

Y20
M10
C40

Y90
M70
C60

Y10
M70
C100

887

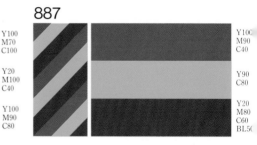

Y100
M90
C40

Y90
C80

Y20
M80
C60
BL50

888

Y60
M90
C80

Y40
C100

Y80
M90
C50
BL50

Deep Colors (1)
These color schemes are similar in color
and brightness to those on the previous
two pages. In general, these have an ap-
pealing folk-art and folk-craft look.

889

Y90
M70
C80

Y100
M100

Y80
M90
C50
BL50

893

Y40
M70
C90

Y50
C90

M90
C100

890

Y100
M80
C60

Y100
C50

Y70
M100
C40

894

Y50
M70
C100

Y100
M100

Y60
M50
BL80

891

Y80
M100
C30

M100

Y90
M70
C80

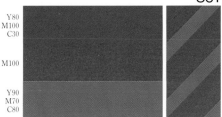

895

Y90
M70
C100

M90
C80

Y90
M90
C80

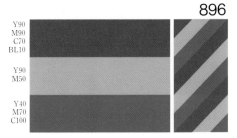

892

Y90
M100
C60

Y80
C90

Y90
M90
C80

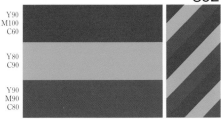

896

Y90
M90
C70
BL10

Y90
M50

Y40
M70
C100

Y90 C50
Y30 M100 C50

Y90 C50
Y10 M70 C100

897

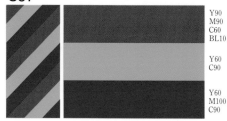

Y90
M90
C60
BL10

Y60
C90

Y60
M100
C90

898

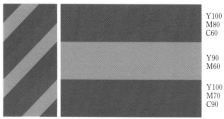

Y100
M80
C60

Y90
M60

Y100
M70
C90

899

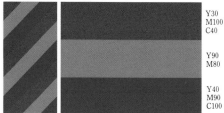

Y30
M100
C40

Y90
M80

Y40
M90
C100

900

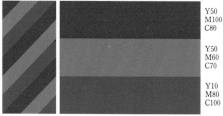

Y50
M100
C80

Y50
M60
C70

Y10
M80
C100

901

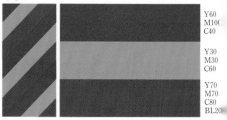

Y60
M100
C40

Y30
M30
C60

Y70
M70
C80
BL20

902

Y100
C100
BL10

Y40
M40
C70

Y30
M80
C70
BL50

903

Y80
M100
C70

Y70
C100
BL10

Y30
M70
C100

904

Y30
M100
C40

Y90
M70
C50

Y90
M100
C80

Deep Colors (2)
The quietness and a certain degree of
brightness in these combinations tell of
approaching autumn.

905

Y60
M100
C40

Y20
M50
C30

Y50
M100
C90

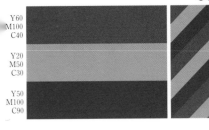

909

Y90
M60
C80

Y100
M80
C20

Y60
M100
C80

906

Y60
M100
C70

Y40
M30
C10

Y80
M60
C100

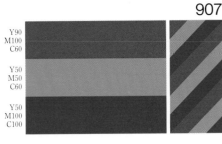

910

Y50
M60
C100

Y90
M50
C60

Y50
M70
C60
BL50

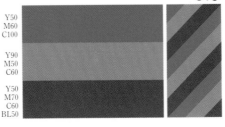

907

Y90
M100
C60

Y50
M50
C60

Y50
M100
C100

911

Y80
C70
BL50

Y90
M100
C50

Y30
M100
C100

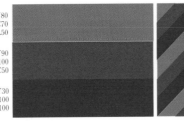

908

Y70
M100
C80

Y70
M50
C40

Y100
C90
BL50

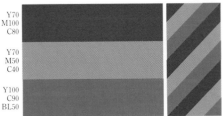

912

Y70
M100
C50

Y80
M70
C70

Y50
M100
C100

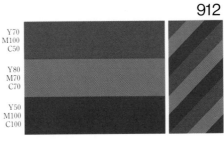

Y100 M100 C50
Y100 C30

Y100 M100 C50
Y40 C70

101

913

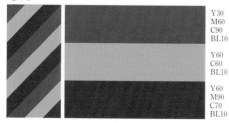

Y30
M60
C90
BL10

Y60
C60
BL10

Y60
M90
C70
BL10

917

Y90
M100
C50

Y40
M50
C50

Y50
M90
C90
BL10

914

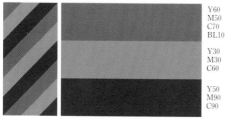

Y60
M50
C70
BL10

Y30
M30
C60

Y50
M90
C90

918

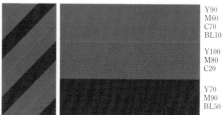

Y90
M60
C70
BL10

Y100
M80
C20

Y70
M90
BL50

915

Y60
M90
C80
BL10

M20
C70
BL10

M70
C90
BL50

919

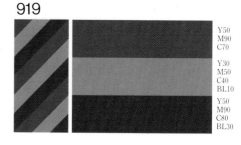

Y50
M90
C70

Y30
M50
C40
BL10

Y50
M90
C80
BL30

916

Y40
M90
C70
BL10

Y80
M60
C20

Y60
M70
C80
BL50

920

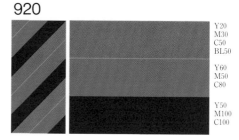

Y20
M30
C50
BL50

Y60
M50
C80

Y50
M100
C100

Deep Colors (3)

This third sequence of deep colors puts
slightly dull colors into combinations that
have a wide number of uses. If all three
tones are equally strong, the result can
seem fashion oriented. Making one color
stronger will serve as an accent.

921

Y90
M40
C90
BL30

Y90
M60
C40
BL20

Y60
M80
C90
BL10

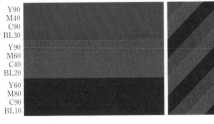

925

Y50
M50
C60
BL50

Y10
M60
BL50

Y30
C100
BL50

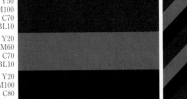

922

Y60
M100
C60
BL10

Y50
M40
C70
BL10

Y90
M80
C80
BL10

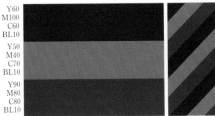

926

Y40
M90
C60
BL30

Y40
M20
C30
BL50

Y30
M30
C30
BL80

923

Y20
M40
C100
BL10

Y80
M60
C80

Y70
M90
C90

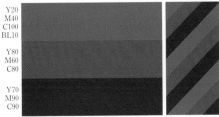

927

Y50
M100
C70
BL10

Y20
M60
C70
BL10

Y20
M100
C80
BL50

924

Y90
M100
C50

Y20
M30
C20
BL50

Y60
M80
C60
BL60

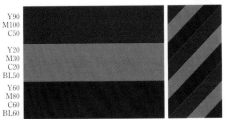

928

Y10
M80
C80
BL50

Y40
M20
C10
BL50

Y60
M50
C80
BL50

Y100 M50
Y100 M100

Y100 M50
Y50 C100

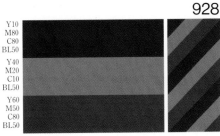

929

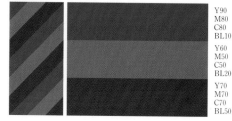

Y90
M80
C80
BL10

Y60
M50
C50
BL20

Y70
M70
C70
BL50

933

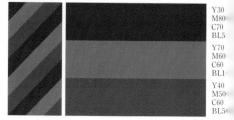

Y30
M80
C70
BL5

Y70
M60
C60
BL1

Y40
M50
C60
BL5

930

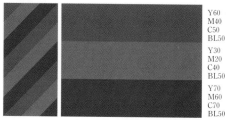

Y60
M40
C50
BL50

Y30
M20
C40
BL50

Y70
M60
C70
BL50

934

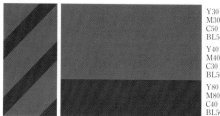

Y30
M30
C50
BL50

Y40
M40
C30
BL50

Y80
M80
C40
BL50

931

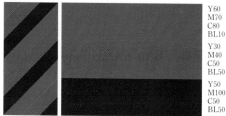

Y60
M70
C80
BL10

Y30
M40
C50
BL50

Y50
M100
C50
BL50

935

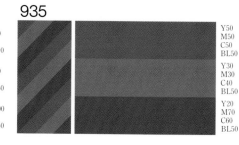

Y50
M50
C50
BL50

Y30
M30
C40
BL50

Y20
M70
C60
BL50

932

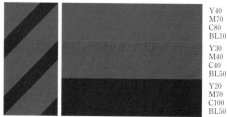

Y40
M70
C80
BL10

Y30
M40
C40
BL50

Y20
M70
C100
BL50

936

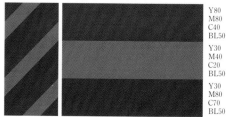

Y80
M80
C40
BL50

Y30
M40
C20
BL50

Y30
M80
C70
BL50

Dark Subdued Colors

In selecting these darker, subdued colors, keep in mind the emotional signals you may want to send. If you want to suppress the color, choose similar tones and thereby increase their darkness or dullness. Compared to other color schemes, they may seem gloomy, but they've been applied very successfully in fashion.

Y60
M50
C80
BL50

Y30
M40
C40
BL50

Y80
M100
C30
BL50

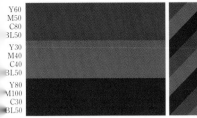

Y40
M50
C50
BL50

Y20
M30
C30
BL50

Y70
C100
BL90

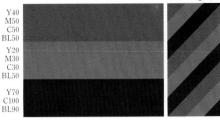

Y70
M40
C100
BL50

Y50
M30
C40
BL50

Y50
M90
C100
BL50

Y60
C90
BL50

Y30
M30
C50
BL50

Y60
M100
BL90

Y80
M80
C20
BL50

Y30
M50
C50
BL50

Y20
M100
C80
BL50

Y40
M60
C50
BL50

Y30
M30
C50
BL50

Y50
M40
C80
BL50

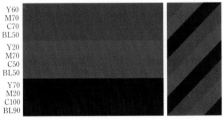

Y20
M60
C60
BL60

Y20
M20
C10
BL50

Y50
M70
BL90

Y60
M70
C70
BL50

Y20
M70
C50
BL50

Y70
M20
C100
BL90

Y50 M50 C60
Y70 M100 C90

Y50 M50 C60
Y70 M60 C100

945

BL30
BL10
BL40

949

BL60
BL30
BL90

946

BL40
BL20
BL60

950

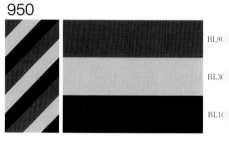

BL90
BL30
BL10

947

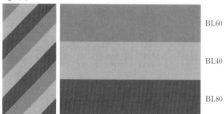

BL60
BL40
BL80

951

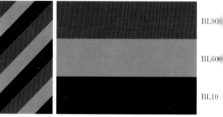

BL90
BL60
BL10

948

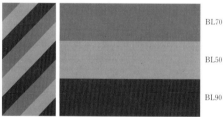

BL70
BL50
BL90

952

BL90
BL80
BL100

Black–Gray–White
Between black and white are the very
versatile grays, covering a full range of
brightness; still, it is difficult to imagine a
scheme made up of only "colorless" grays.
Gray offers a contrast in brightness, and
with black and white it is a basic color in
interior and environmental design and
fashion.

106

953
BL20
BL40

954
BL30
BL60

955
BL60
BL90

956
BL80
BL100

957
BL30
BL10
BL80

958
BL40
BL20
BL90

959
BL60
BL30
BL100

960
BL30
BL100

BL100

BL100

107

961

Y70

BL20

BL90

965

Y20
C60

Y30
M20
C10

Y20
M10
C80
BL5

962

M60

BL20

BL90

966

Y30
C50

Y50

Y60
M90
C30
BL5

963

Y30
C70

BL20

BL90

967

Y50
M50

Y50

Y90
M60
C100

964

Y30
M50

BL20

BL90

968

M50
C10

Y50
M10

Y40
M70
C90

Effects of Contrast (1)
These examples contain two light colors and one dark color. They suggest Hawaiian shirts, calypso music, and offbeat tropical settings.

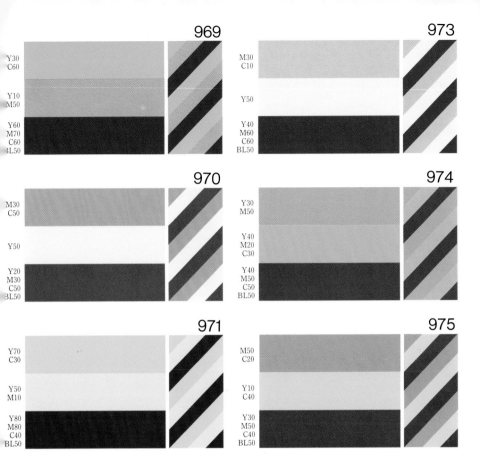

969

Y30
C60

Y10
M50

Y60
M70
C60
BL50

973

M30
C10

Y50

Y40
M60
C60
BL50

970

M30
C50

Y50

Y20
M30
C50
BL50

974

Y30
M50

Y40
M20
C30

Y40
M50
C50
BL50

971

Y70
C30

Y50
M10

Y80
M80
C40
BL50

975

M50
C20

Y10
C40

Y30
M50
C40
BL50

972

Y10
C60

Y30
C40

Y70
M100
C100

976

Y10
M10
C50

Y50
M10
CJ0

Y90
M90
C80

Y10 M50
Y80 M80 C80

Y20 C60
Y80 M80 C80

977

Y50
M20
C20

Y40

Y60
M40
C40

981

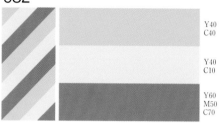

Y50
M50

Y30
M10
C30

Y60
M70
C70

978

Y30
M40

Y40
M10

Y50
M50
C70

982

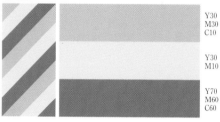

Y40
C40

Y40
C10

Y60
M50
C70

979

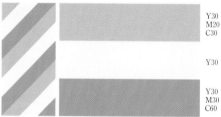

Y30
M20
C30

Y30

Y30
M30
C60

983

Y30
M30
C10

Y30
M10

Y70
M60
C60

980

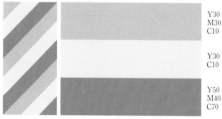

Y30
M30
C10

Y30
C10

Y50
M40
C70

984

Y30
C50

Y30
M20
C30

Y30
M30
C70

Effects of Contrast (2)

Color schemes on these pages are based
on colors that are somewhat softer than
those on the preceding pages. The differ-
ences in bright and quiet colors result in
color groupings more suitable for interior
design than fabric or fashion.

985

Y30
M40
C30

Y20
M20
C30

Y40
M70
C50

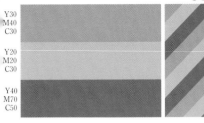

989

Y50
M40
C10

Y50
M70

Y90
M70
C70

986

M30
C40

Y30
C30

Y70
M60
C70

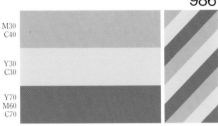

990

Y20
M50
C10

Y40
M10
C20

Y90
M80
C70

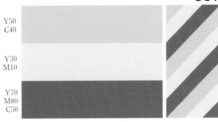

987

Y70
M40
C30

Y40
M10
C20

Y60
M50
C60

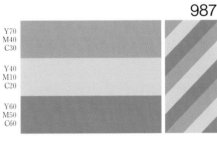

991

Y50
C40

Y30
M10

Y70
M80
C50

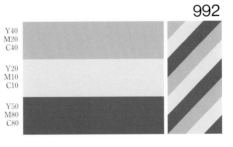

988

Y40
M30
C50

Y30
M10
C30

Y40
M80
C50

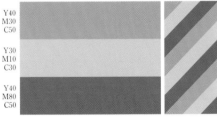

992

Y40
M20
C40

Y20
M10
C10

Y50
M80
C80

Y40 M10 C20
Y90 M40 C30

Y40 M10 C20
Y60 M60 C70

993

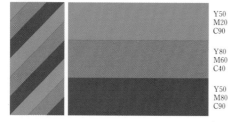

Y50
M20
C90

Y80
M60
C40

Y50
M80
C90

997

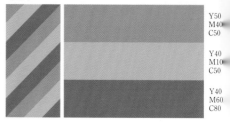

Y50
M40
C50

Y40
M10
C50

Y40
M60
C80

994

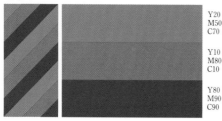

Y20
M50
C70

Y10
M80
C10

Y80
M90
C90

998

Y40
M10
C70

Y40
M40
C20

Y40
M70
C70

995

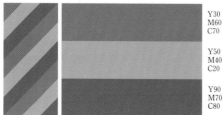

Y30
M60
C70

Y50
M40
C20

Y90
M70
C80

999

Y20
M80
C20

Y40
M20
C50

Y80
M80
C80

996

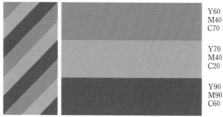

Y60
M40
C70

Y70
M40
C20

Y90
M90
C60

1000

Y90
M70
C40

Y30
M30
C10

Y40
M70
C90

Free Color Schemes (1)
These are mid-range colors arranged for
a pleasant, restful effect. The combina-
tions can be widely used, from fashion to
interior design.

112

1001

Y70
M60
C20

Y40
M40
C10

Y80
M60
C80

1005

Y70
M50
C50

Y40
M40
C10

Y30
M60
C80

1002

Y20
M80
C20

Y60
M50
C20

Y80
M60
C70

1006

Y80
M70
C60

Y20
M50
C20

Y60
M60
C90

1003

Y50
M40
C80

Y30
M50
C10

Y60
M90
C70

1007

Y70
M50
C60

Y50
M50
C20

Y30
M90
C40

1004

Y60
M50
C70

Y20
M20
C70

Y30
M60
C80

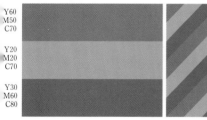

1008

Y40
M30
C90

Y10
M60
C10

Y40
M70
C90

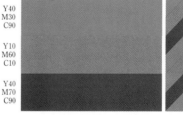

Y40 M20 C50
Y40 M60 C70

Y40 M20 C50
Y80 M70 C70

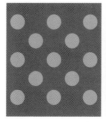

1009

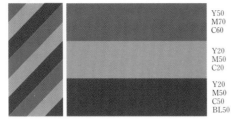

Y50
M70
C60

Y20
M50
C20

Y20
M50
C50
BL50

1013

Y70
M90
C40

Y40
M40
C50

Y50
M90
C90

1010

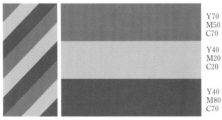

Y70
M50
C70

Y40
M20
C20

Y40
M80
C70

1014

Y60
M90
C70

Y40
M40
C20

Y30
M60
C80

1011

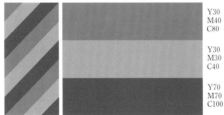

Y30
M40
C80

Y30
M30
C40

Y70
M70
C100

1015

Y40
M70
C40

Y40
M40
C20

Y80
M40
C80

1012

Y60
M50
C70

Y20
M30
C50

Y90
M90
C80

1016

Y60
M40
C50

Y40
M20
C20

Y40
M60
C80

Free Color Schemes (continued)

1017

Y40
M80
C50

Y50
M40
C10

Y20
C90
BL50

1021

Y60
M40
C50
BL20

Y20
M40
C30
BL10

Y40
M70
C70
BL10

1018

Y50
M90
C70

Y40
M10
C20

Y20
M40
C50
BL50

1022

Y90
M60
C50

Y40
M30
C40

Y90
M50
C70

1019

Y30
M40
C20
BL50

Y30
M30
C40
BL10

Y80
M30
C90
BL10

1023

Y60
M80
C40

Y30
M40
C30
BL10

Y80
M80
C80

1020

Y80
M80
C40

Y50
M30
C50

Y90
M60
C70

1024

Y90
M70
C70

Y40
M30
C40

Y20
M80
BL50

Y40 M30 C30
Y70 M50 C70

Y40 M30 C30
Y50 M90 C80

115

1025

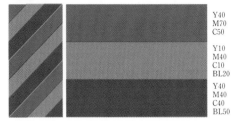

Y40
M70
C50

Y10
M40
C10
BL20

Y40
M40
C40
BL50

1029

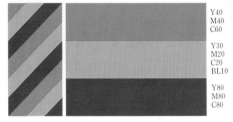

Y40
M40
C60

Y30
M20
C20
BL10

Y80
M80
C80

1026

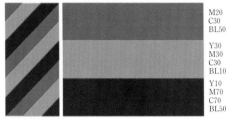

M20
C30
BL50

Y30
M30
C30
BL10

Y10
M70
C70
BL50

1030

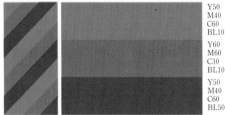

Y60
M40
C60
BL10

Y30
M30
C10
BL10

Y70
M70
C60
BL50

1027

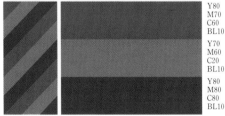

Y50
M40
C60
BL10

Y60
M60
C30
BL10

Y50
M40
C60
BL50

1031

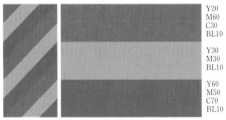

Y20
M60
C30
BL10

Y30
M30
BL10

Y60
M50
C70
BL10

1028

Y80
M70
C60
BL10

Y70
M60
C20
BL10

Y80
M80
C80
BL10

1032

Y30
M60
C60
BL10

Y30
M20
C10
BL50

Y40
M30
C70
BL50

Free Color Schemes (2)
Using three smoky, subdued colors produces natural and quiet color schemes full of earth tones—subtle, graceful, and quiet.

1033

Y20
M50
C20
BL10

Y30
M30
BL10

Y60
M60
C60
BL10

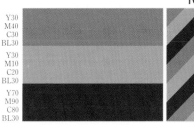

1037

Y30
M30
C40
BL50

Y10
M40
C40
BL10

Y30
M80
C80
BL50

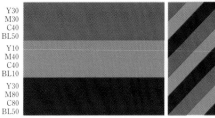

1034

Y60
M50
C60

Y40
M30
C30
BL10

Y70
M60
C80
BL10

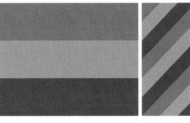

1038

Y60
M50
C50
BL10

Y30
M30
C30
BL10

Y80
M70
C80
BL10

1035

Y30
M40
C30
BL30

Y30
M10
C20
BL30

Y70
M90
C80
BL30

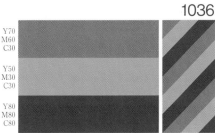

1039

Y70
M50
C60
BL10

Y50
M40
C10
BL10

Y90
M80
C80
BL10

1036

Y70
M60
C30

Y50
M30
C30

Y80
M80
C80

1040

Y80
M70
C60
BL20

Y20
M20
BL50

Y70
M70
C80
BL20

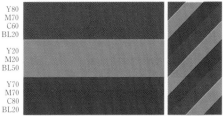

Y30 M30 C30
Y60 M70 C70

Y30 M30 C30
Y80 M70 C80

117

1041

M100
C100

Y30
C100

Y50
M50
C50
BL100

1042

M100
C30

Y80
M100

Y50
M50
C50
BL100

1043

M100
C70

Y100
C100

Y50
M50
C50
BL100

1044

Y100
M100

Y100
M30

Y50
M50
C50
BL100

1045

M50
C100

Y30
M100

Y50
M50
C50
BL100

1046

M30
C100

Y100
M10

Y50
M50
C50
BL100

1047

M100
C70

Y100
M70

Y50
M50
C50
BL100

1048

M100
C100

Y100
M100

Y50
M50
C50
BL100

Black and Vivid Colors

Again, the addition of black is always striking and dramatic. This page demonstrates the graphic power of combining equal proportions of two strong colors and black.

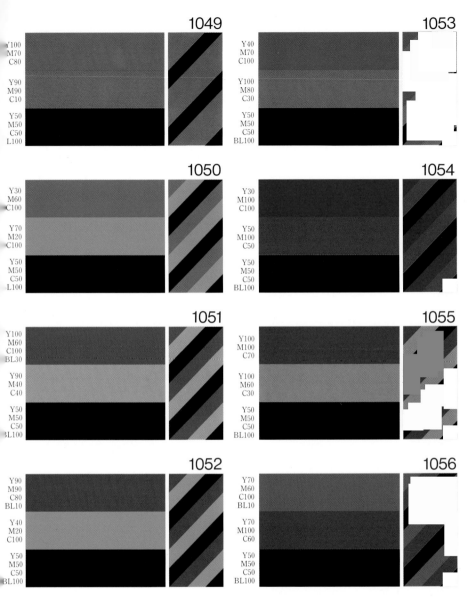

1049

Y100
M70
C80

Y90
M90
C10

Y50
M50
C50
L100

1050

Y30
M60
C100

Y70
M20
C100

Y50
M50
C50
L100

1051

Y100
M60
C100
BL30

Y90
M40
C40

Y50
M50
C50
BL100

1052

Y90
M90
C80
BL10

Y40
M20
C100

Y50
M50
C50
BL100

1053

Y40
M70
C100

Y100
M80
C30

Y50
M50
C50
BL100

1054

Y30
M100
C100

Y50
M100
C50

Y50
M50
C50
BL100

1055

Y100
M100
C70

Y100
M60
C30

Y50
M50
C50
BL100

1056

Y70
M60
C100
BL10

Y70
M100
C60

Y50
M50
C50
BL100

Black and Deep Colors

Combined with more somber colors black intensifies their depth and richness.

BL100
Y90 M40 C30

BL100
Y100 M60 C70

119

1057

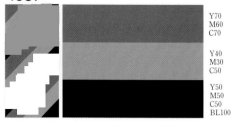

Y70
M60
C70

Y40
M30
C50

Y50
M50
C50
BL100

1061

Y60
M50
C70

Y30
M40
C50

Y50
M50
C50
BL

1058

Y50
M70
C80

Y20
M50
C30

Y50
M50
C50
BL100

1062

Y60
M50
C80

Y40
M50
C10

Y50
M50
C50
BL1

1059

Y30
M40
C70

Y30
M30
C30

Y50
M50
C50
BL100

1063

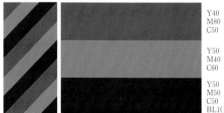

Y60
M80
C40

Y40
M40
C40

Y50
M50
C50
BL1

1060

Y40
M30
C70

Y40
M30
C40

Y50
M50
C50
BL100

1064

Y40
M80
C50

Y50
M40
C60

Y50
M50
C50
BL10

Black and Medium Colors

Next to these restrained colors, black becomes dominant and the resulting color scheme is sophisticated and fashionable. Medium colors are basically soft; black has a bracing effect and helps to define them.

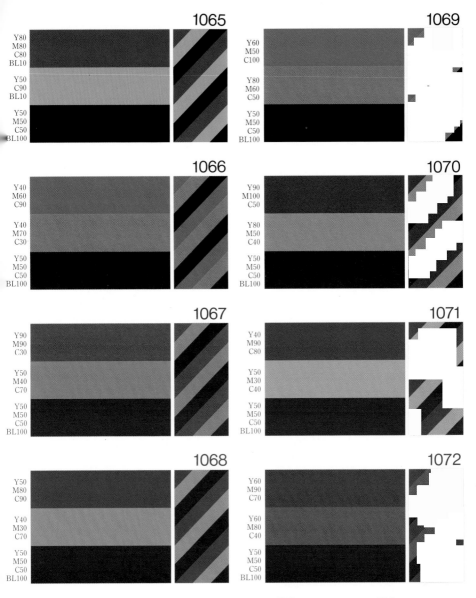

1065

Y80
M80
C80
BL10

Y50
C90
BL10

Y50
M50
C50
BL100

1066

Y40
M60
C90

Y40
M70
C30

Y50
M50
C50
BL100

1067

Y90
M90
C30

Y50
M40
C70

Y50
M50
C50
BL100

1068

Y50
M80
C90

Y40
M30
C70

Y50
M50
C50
BL100

1069

Y60
M50
C100

Y80
M60
C50

Y50
M50
C50
BL100

1070

Y90
M100
C50

Y80
M50
C40

Y50
M50
C50
BL100

1071

Y40
M90
C80

Y50
M30
C40

Y50
M50
C50
BL100

1072

Y60
M90
C70

Y60
M80
C40

Y50
M50
C50
BL100

BL100
Y90 M80 C30

BL100
Y90 M90 C80

1073

Y20
C70

M50
C60

1077

Y40
C60

Y20
C80

1074

Y70
M30

Y50
M70

1078

M60
C10

M70
C60

1075

Y90
C40

M60
C60

1079

Y80
M40

M50
C70

1076

Y90
M70

M20
C90

1080

Y20
M80

Y70
C90

White with Vivid Colors
Adding white both brightens and lightens
color schemes. This results in combina-
tions that are sporty and refreshing.
These examples evoke flag images as
well.

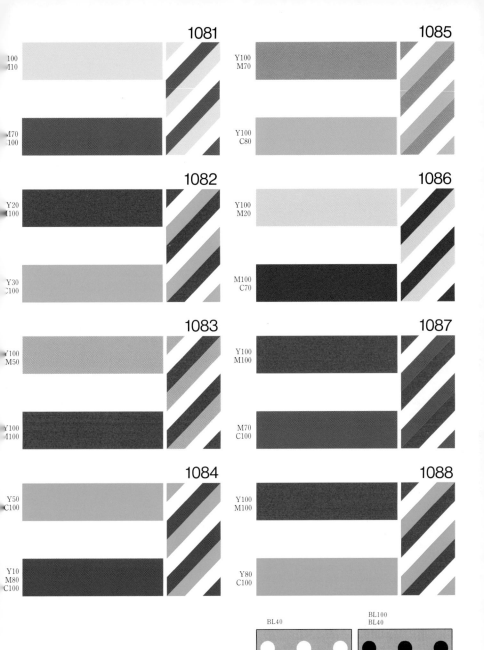

1081

100
M10

M70
C100

1085

Y100
M70

Y100
C80

1082

Y20
M100

Y30
C100

1086

Y100
M20

M100
C70

1083

Y100
M50

Y100
M100

1087

Y100
M100

M70
C100

1084

Y50
C100

Y10
M80
C100

1088

Y100
M100

Y80
C100

BL40

BL100
BL40

123

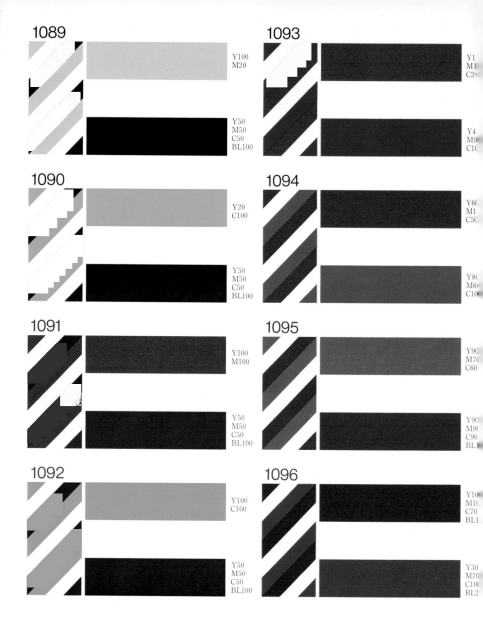

1089
Y100
M20

Y50
M50
C50
BL100

1093
Y1
M1
C2

Y4
M9
C1(

1090
Y20
C100

Y50
M50
C50
BL100

1094
Y6(
M1
C5(

Y8(
M6
C10

1091
Y100
M100

Y50
M50
C50
BL100

1095
Y90
M70
C60

Y9(
M90
C90
BL

1092
Y100
C100

Y50
M50
C50
BL100

1096
Y10
M1(
C70
BL1

Y30
M7(
C10(
BL2

White with Other Colors

Like those on the previous two pages,
these color schemes are lighter because
of the addition of white. Substituting gray
or beige for white is often too powerful
and may destroy tonal harmony.

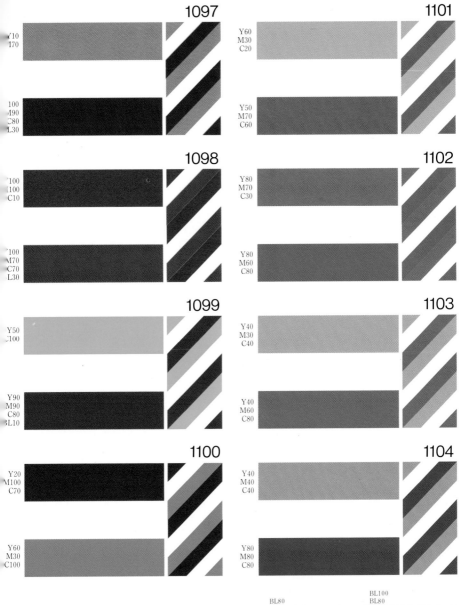

1097

Y10
M70

M100
M90
C80
BL30

1098

Y100
M100
C10

Y100
M70
C70
BL30

1099

Y50
C100

Y90
M90
C80
BL10

1100

Y20
M100
C70

Y60
M30
C100

1101

Y60
M30
C20

Y50
M70
C60

1102

Y80
M70
C30

Y80
M60
C80

1103

Y40
M30
C40

Y40
M60
C80

1104

Y40
M40
C40

Y80
M80
C80

BL80

BL100
BL80

Concentration Scale

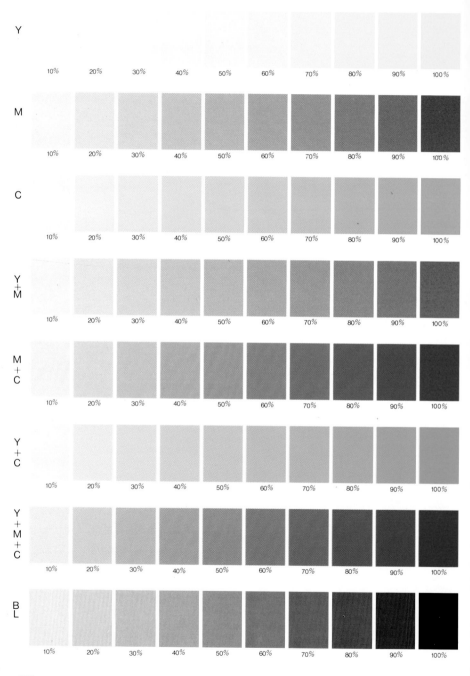

Y
10% 20% 30% 40% 50% 60% 70% 80% 90% 100%

M
10% 20% 30% 40% 50% 60% 70% 80% 90% 100%

C
10% 20% 30% 40% 50% 60% 70% 80% 90% 100%

Y
+
M
10% 20% 30% 40% 50% 60% 70% 80% 90% 100%

M
+
C
10% 20% 30% 40% 50% 60% 70% 80% 90% 100%

Y
+
C
10% 20% 30% 40% 50% 60% 70% 80% 90% 100%

Y
+
M
+
C
10% 20% 30% 40% 50% 60% 70% 80% 90% 100%

B
L
10% 20% 30% 40% 50% 60% 70% 80% 90% 100%

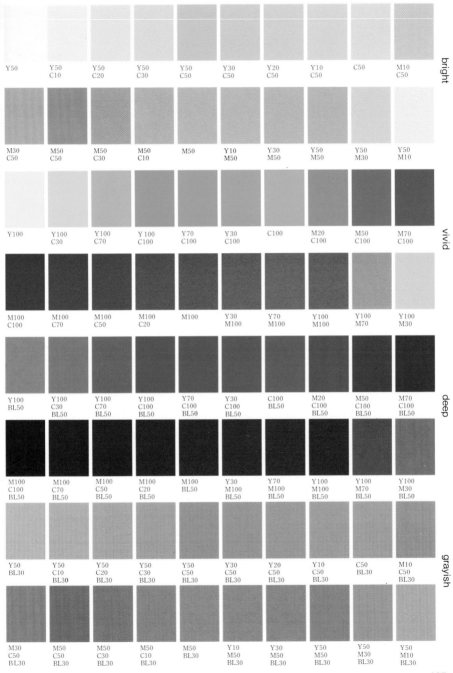